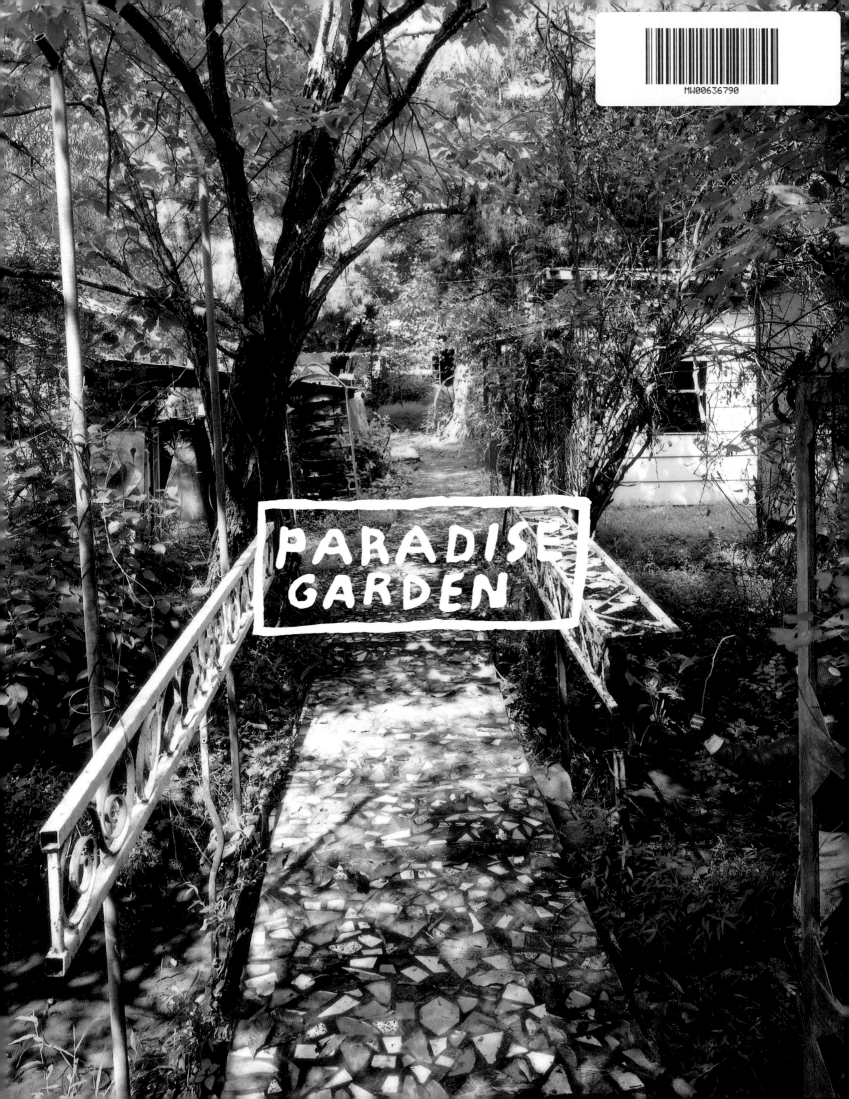

PARADISE
GARDEN

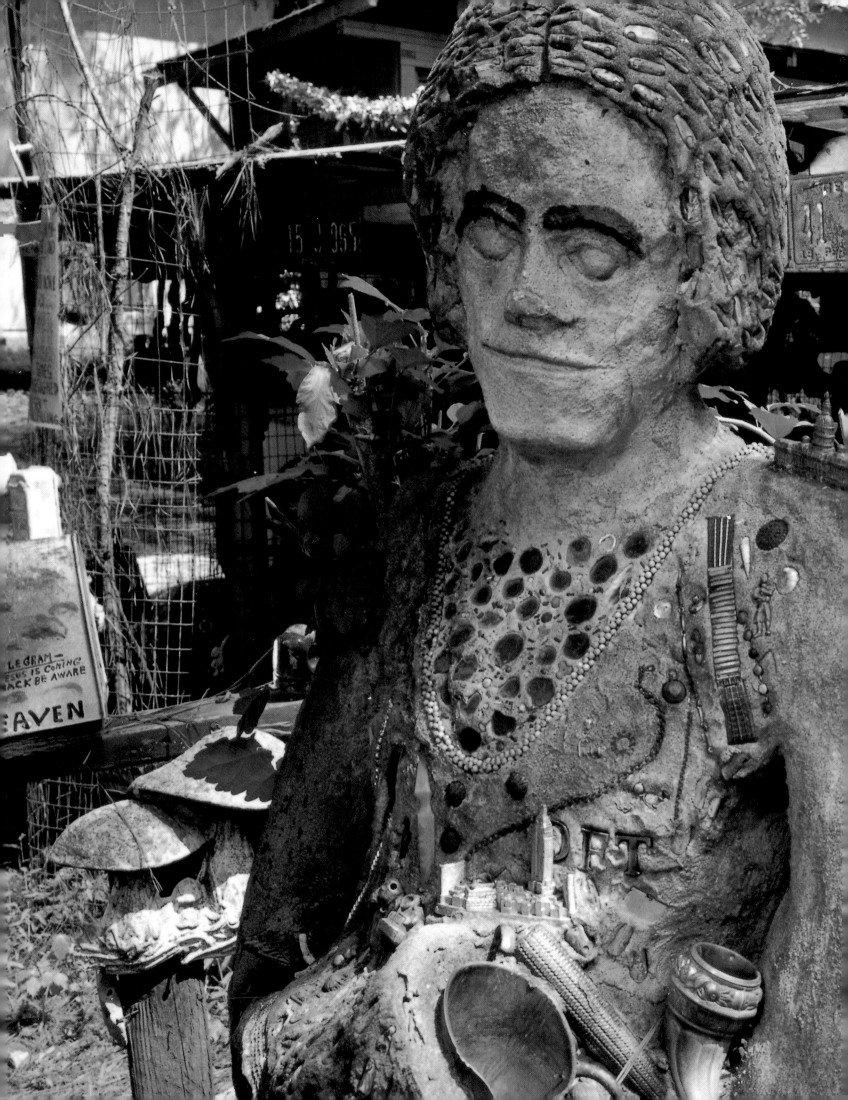

PARADISE GARDEN

A Trip through Howard Finster's Visionary World

By Robert Peacock with Annibel Jenkins

Photography by Mary Ellen Mark, Karekin Goekjian, David Graham, and Alan David

CHRONICLE BOOKS

SAN FRANCISCO

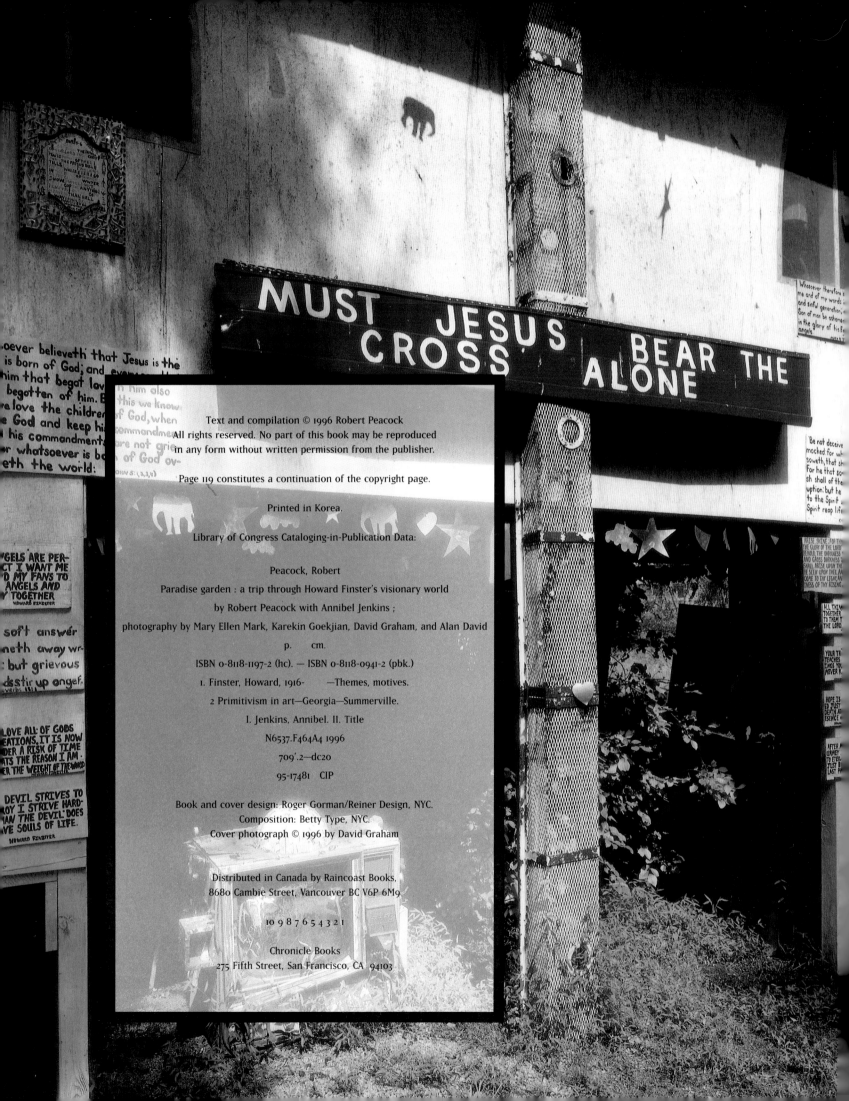

Printed in Korea.

Library of Congress Cataloging-in-Publication Data:

Peacock, Robert

Paradise garden : a trip through Howard Finster's visionary world

by Robert Peacock with Annibel Jenkins ;

photography by Mary Ellen Mark, Karekin Goekjian, David Graham, and Alan David

p. cm.

ISBN 0-8118-1197-2 (hc). — ISBN 0-8118-0941-2 (pbk.)

1. Finster, Howard, 1916- —Themes, motives.

2 Primitivism in art—Georgia—Summerville.

I. Jenkins, Annibel. II. Title

N6537.F464A4 1996

709'.2—dc20

95-17481 CIP

Book and cover design: Roger Gorman/Reiner Design, NYC.
Composition: Betty Type, NYC.
Cover photograph © 1996 by David Graham

Distributed in Canada by Raincoast Books,
8680 Cambie Street, Vancouver BC V6P 6M9

10 9 8 7 6 5 4 3 2 1

Chronicle Books
275 Fifth Street, San Francisco, CA 94103

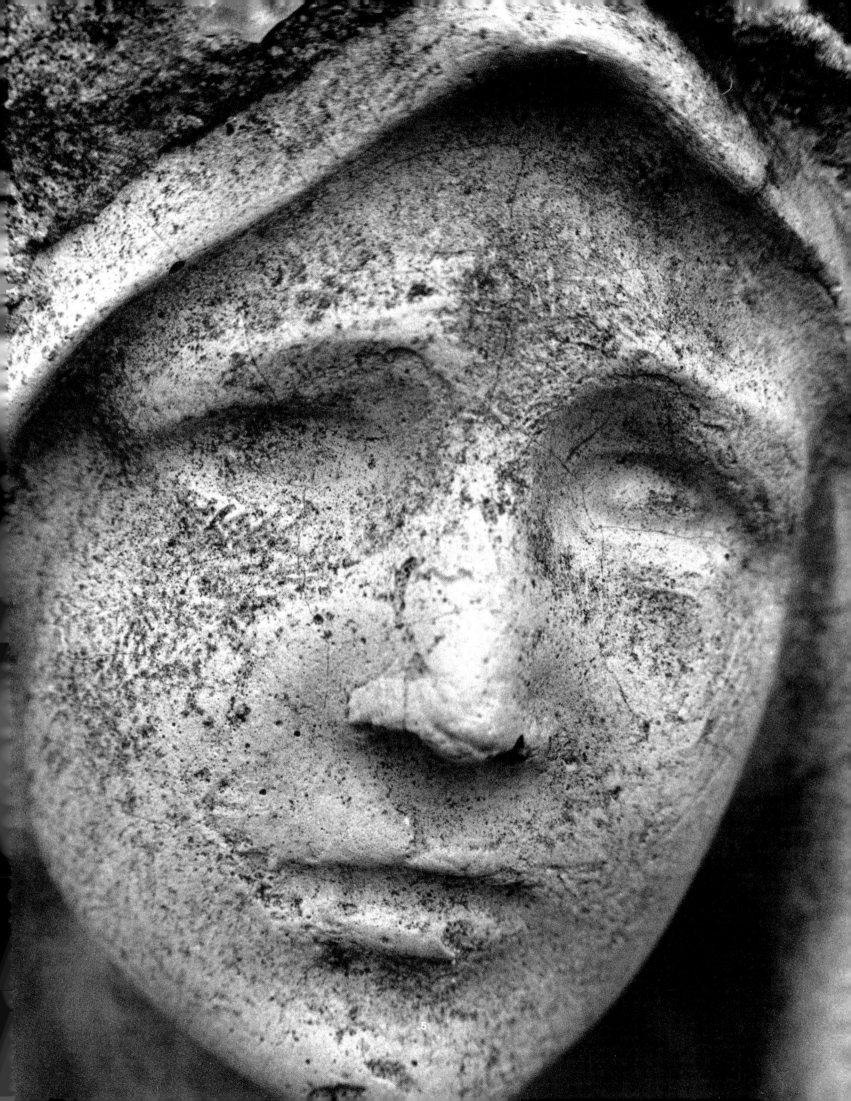

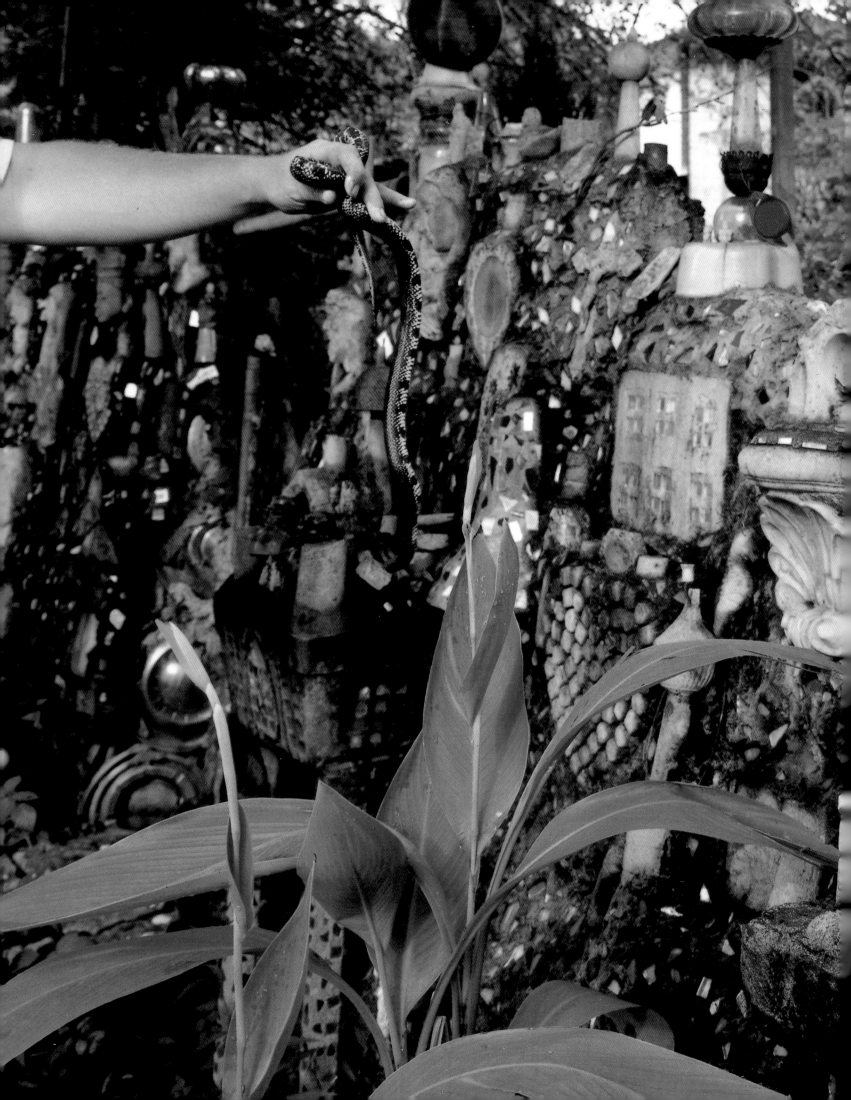

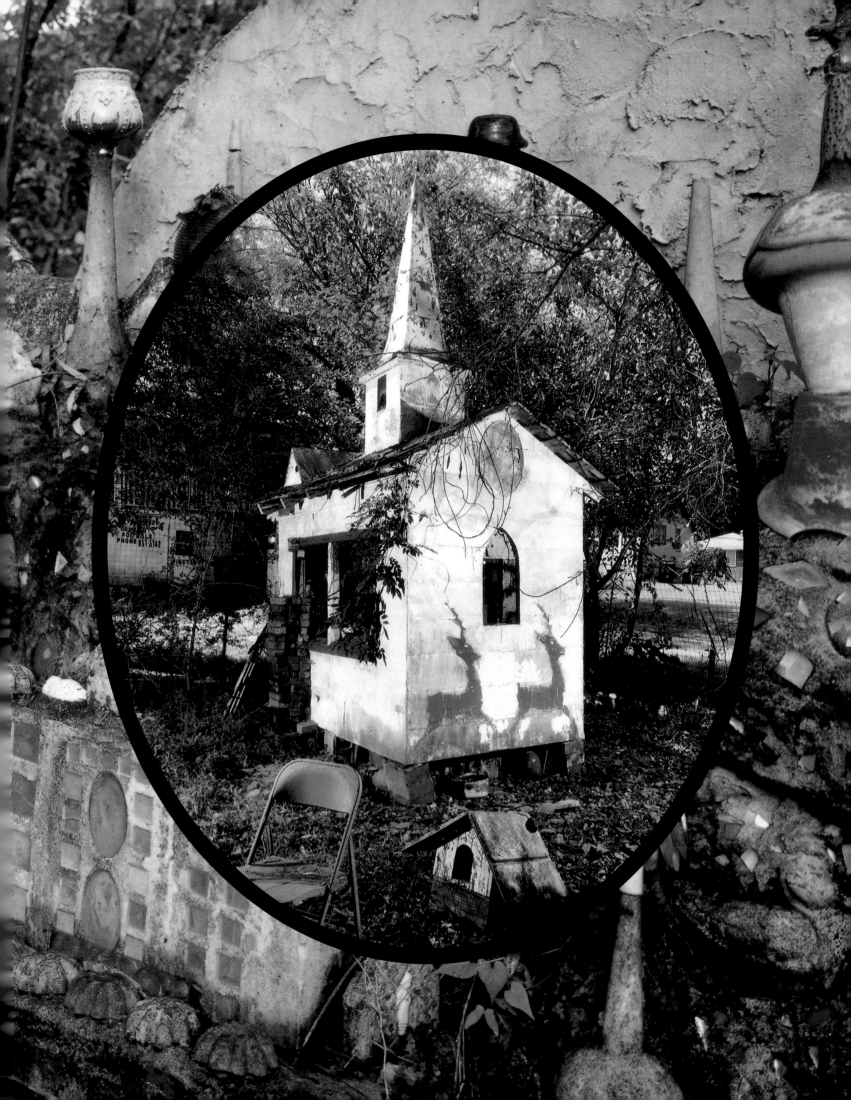

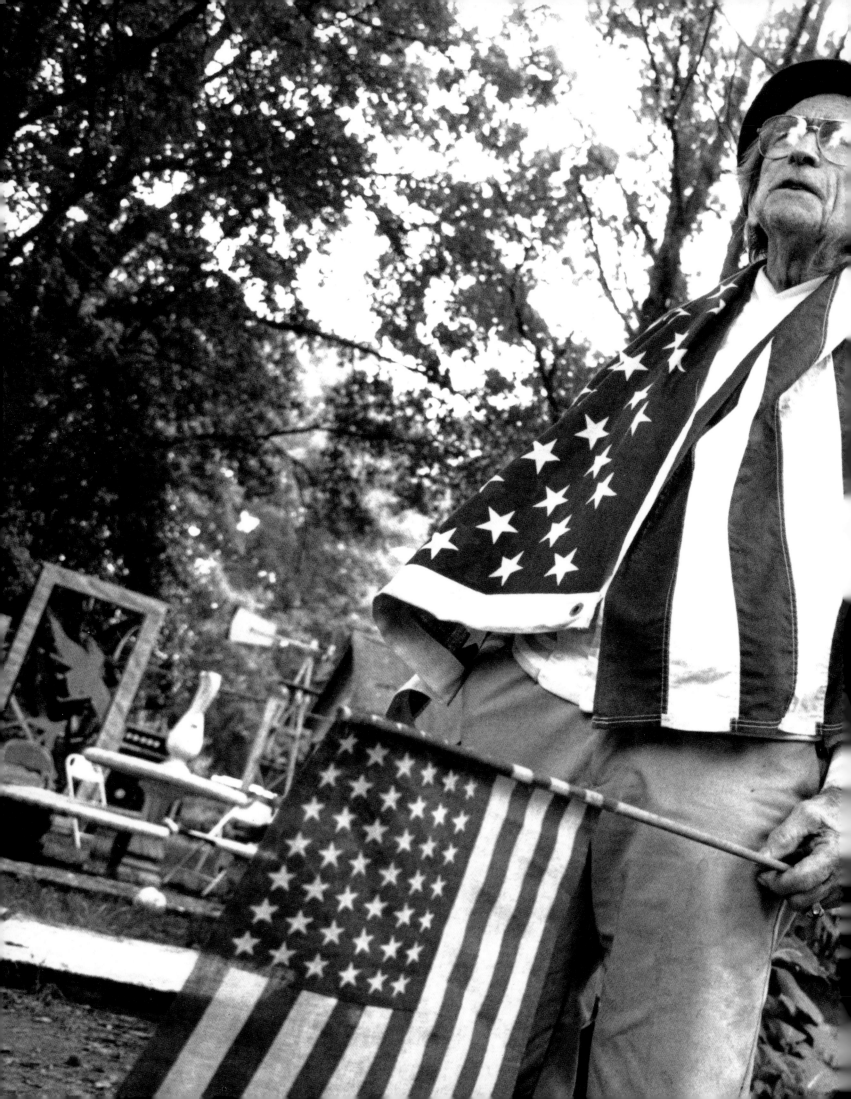

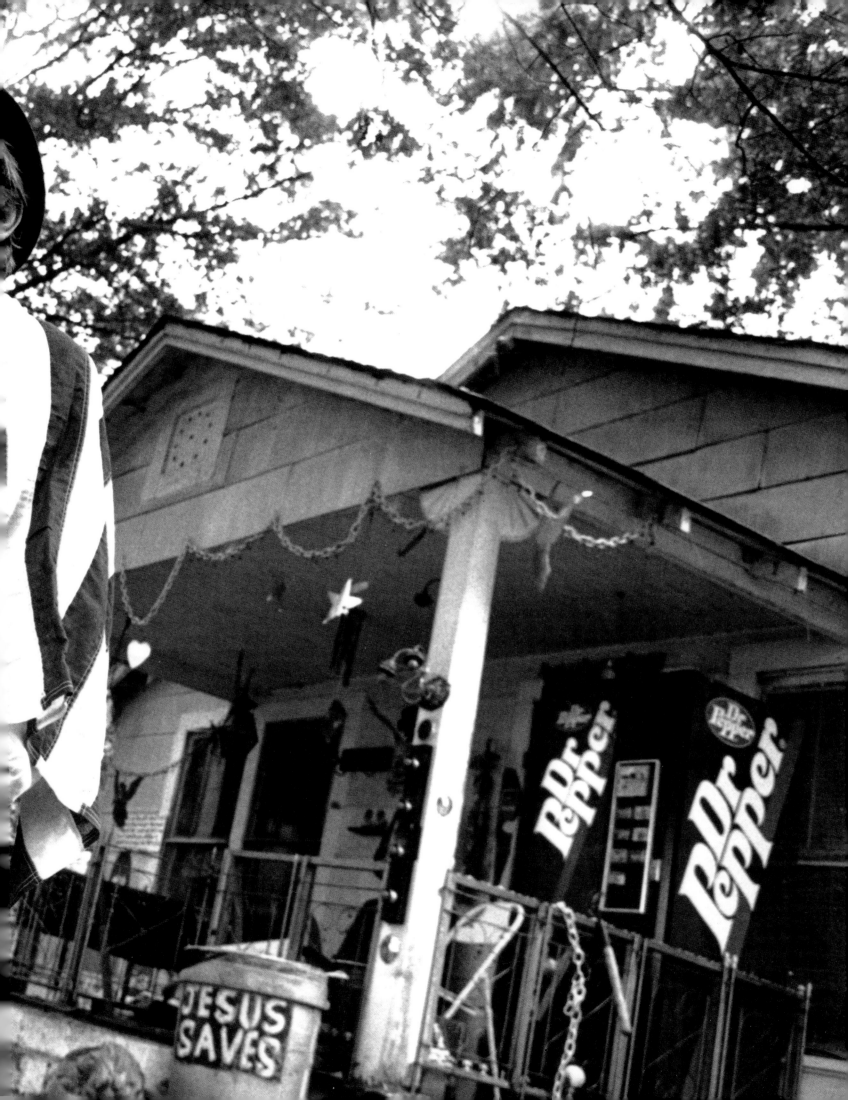

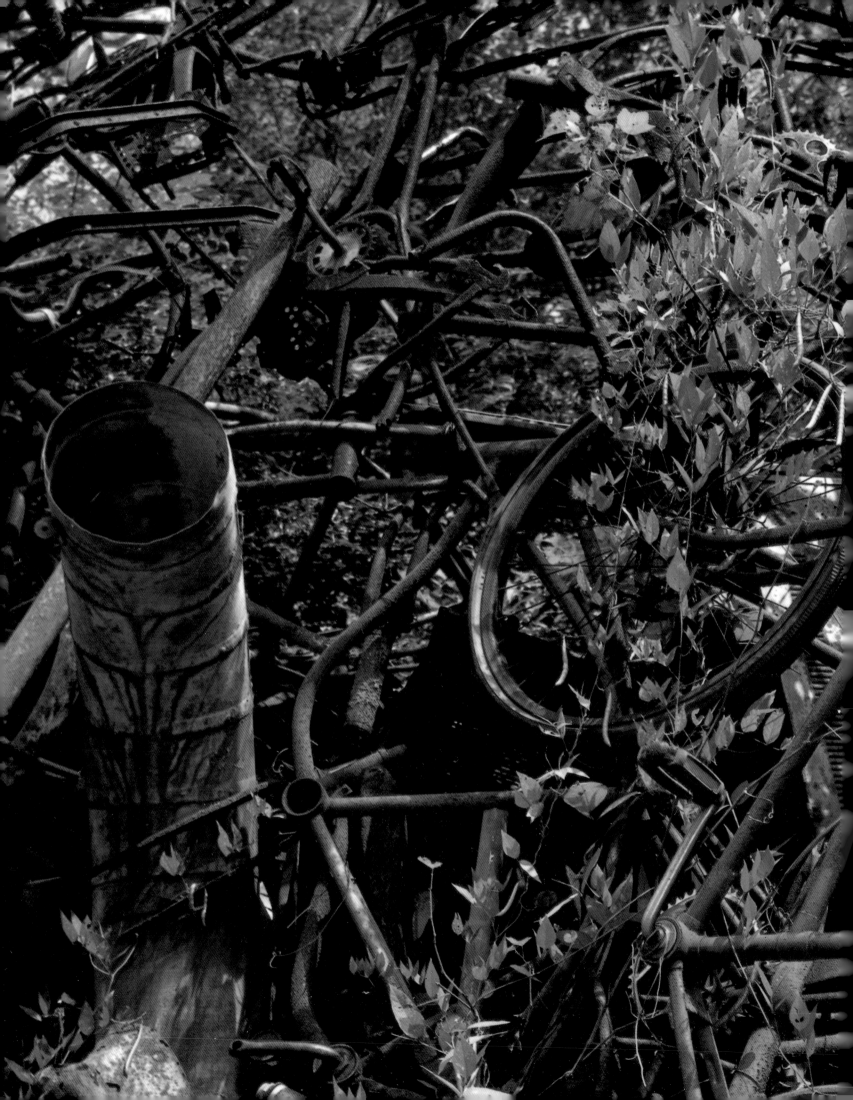

Introduction by Robert Peacock

Paradise Garden is a wild and wonderful hodgepodge filled with hand-constructed buildings and the cement moldings and mounds that are the sculptures and sacred art of Howard Finster. In the past fifteen-some years, Finster has welcomed tens of thousands of visitors to Paradise Garden. Free to all, the garden is located approximately a hundred miles northwest of Atlanta, in a valley near the edge of the Blue Ridge Mountains.

The four-acre garden is full of trees and bushes that in winter lie dormant and naked, revealing the intricacy of form and exposing in full light the volume and detail of the garden's constructions. With the spring, the foliage bursts into full life again, yielding flowers and fruits and a rich array of greens that cover and cradle the garden throughout the summer. At any time of the year visitors are welcome to behold the garden's wonders and to experience the fascinating presence of Howard Finster.

Entry to the garden is on its south side, off a rambling rural road. Passing a mailbox bearing Finster's name in bold paint, down a cement walkway, one comes to a colorfully decorated house. Originally Finster's own home and later his painting studio, this structure is now known as the work house because it's used to sell various items of Finster art, including paintings and cut-outs as well as posters and T-shirts imprinted with Finster designs.

Beyond the work house looms the Folk Art Chapel, the largest structure in the garden. The chapel is a five-story tower, complete with steeple, which houses an assortment of books, articles, and photographs given to Finster over the years by friends and visitors to the garden. In addition to being a repository, it functions as a display gallery for Finster's art and artifacts.

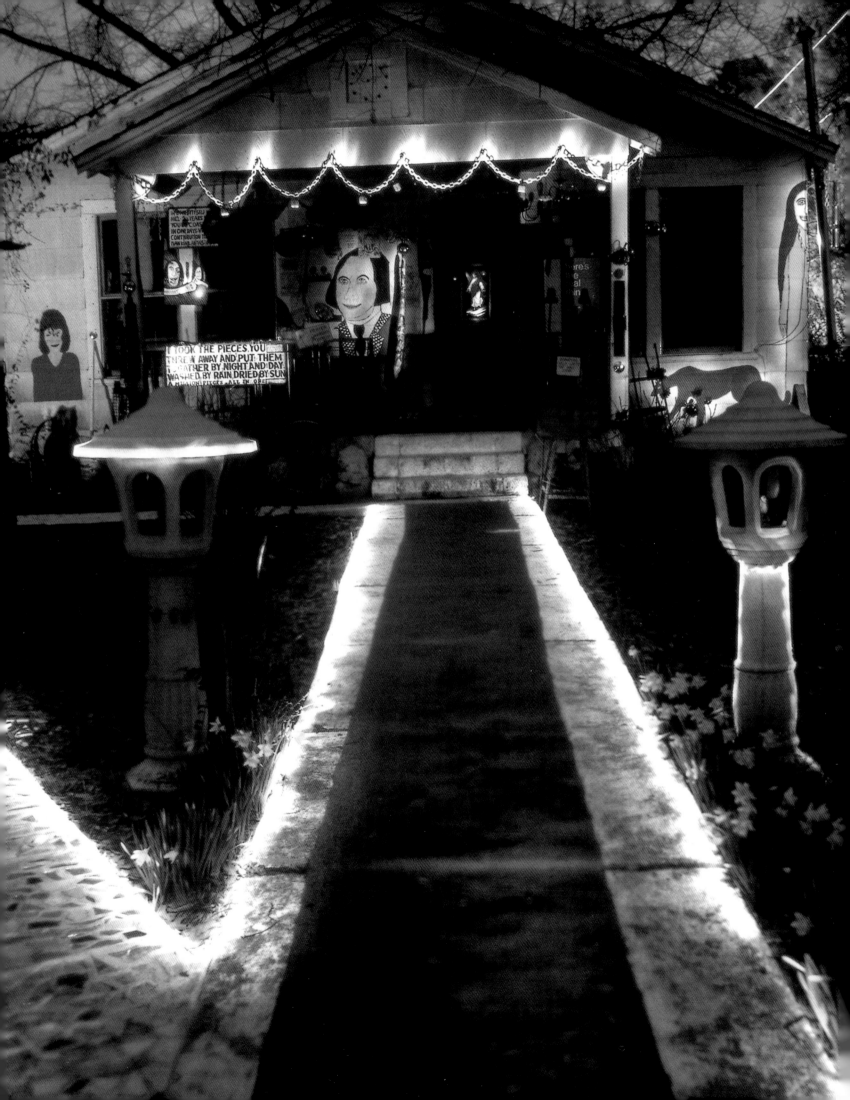

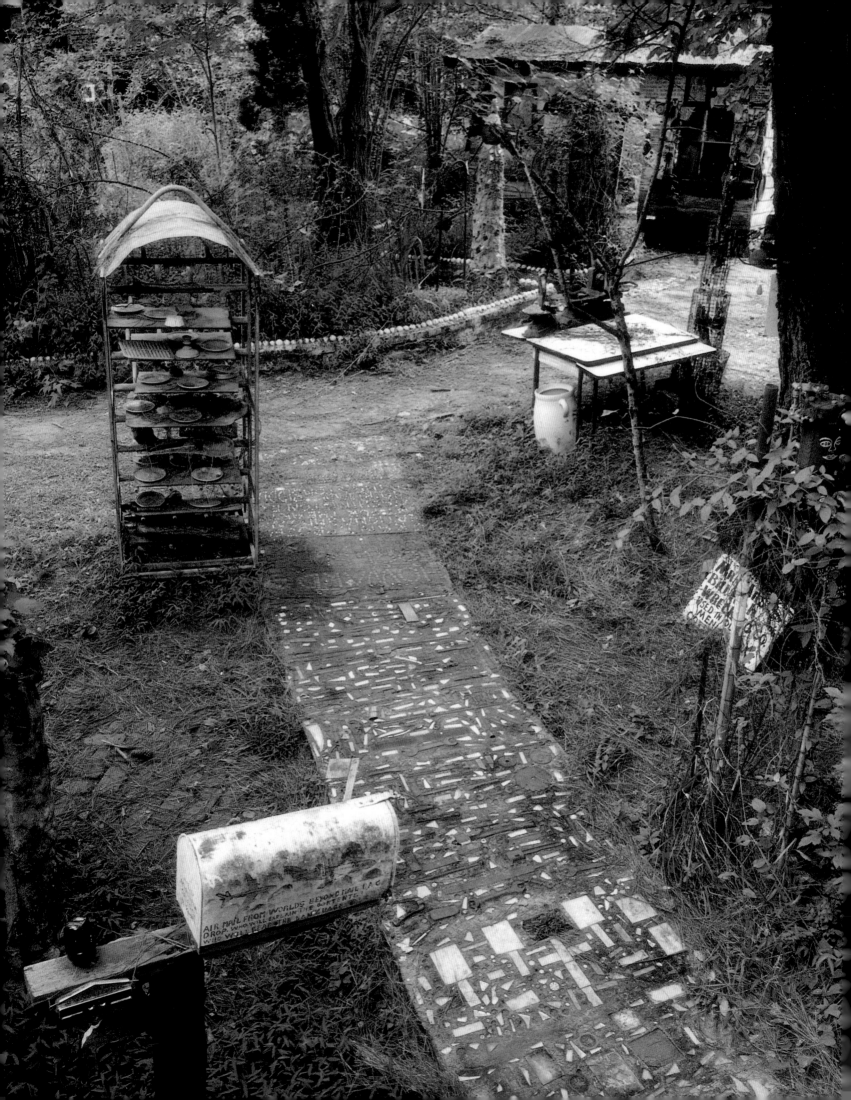

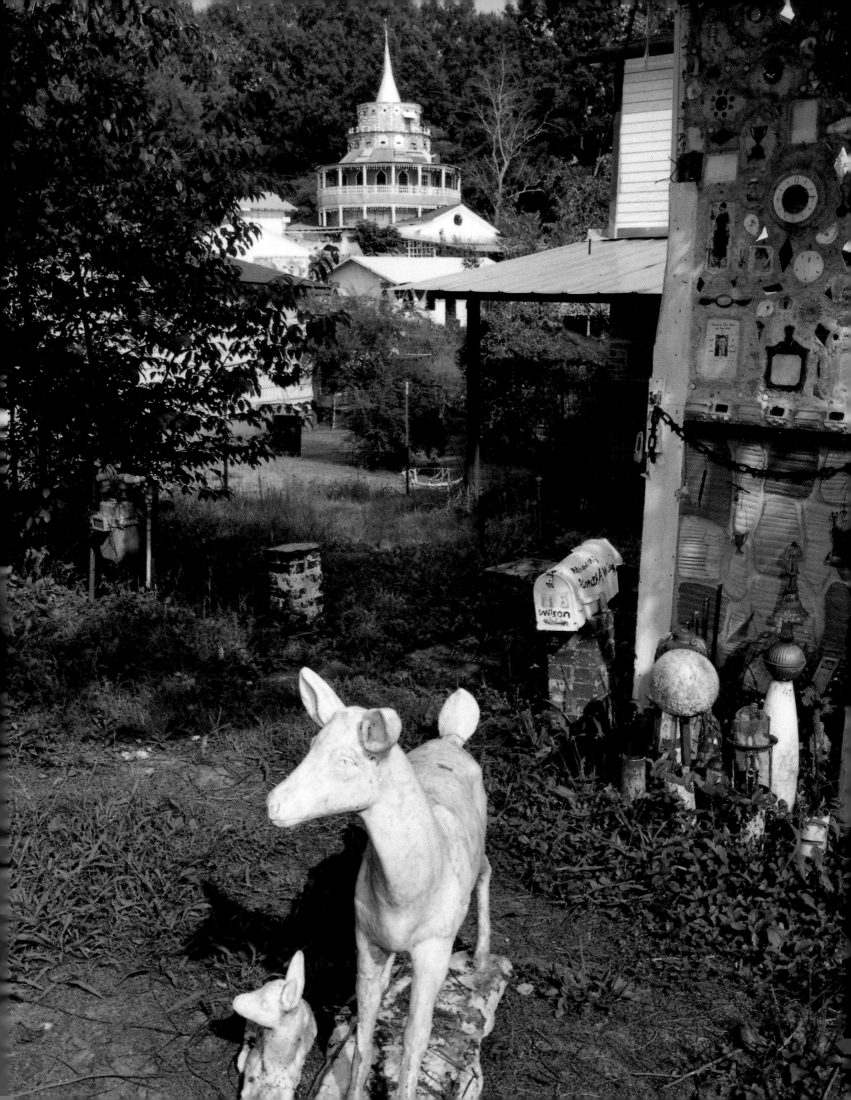

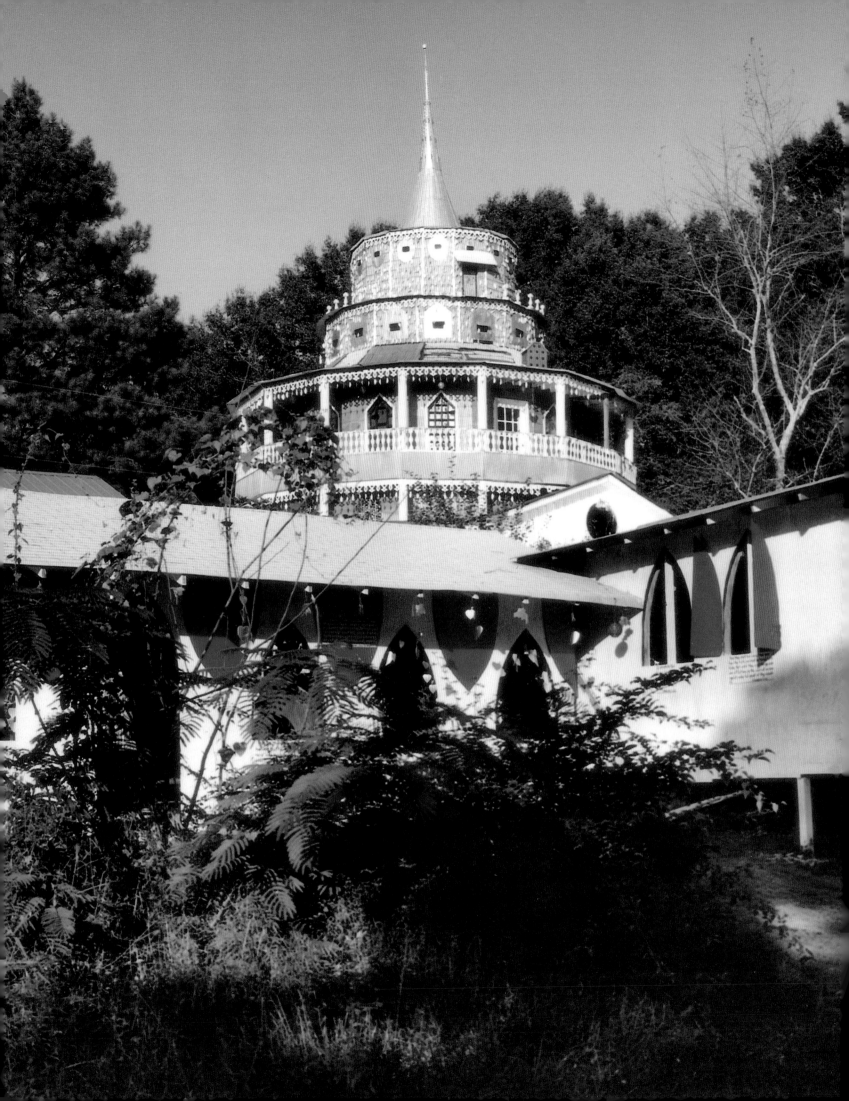

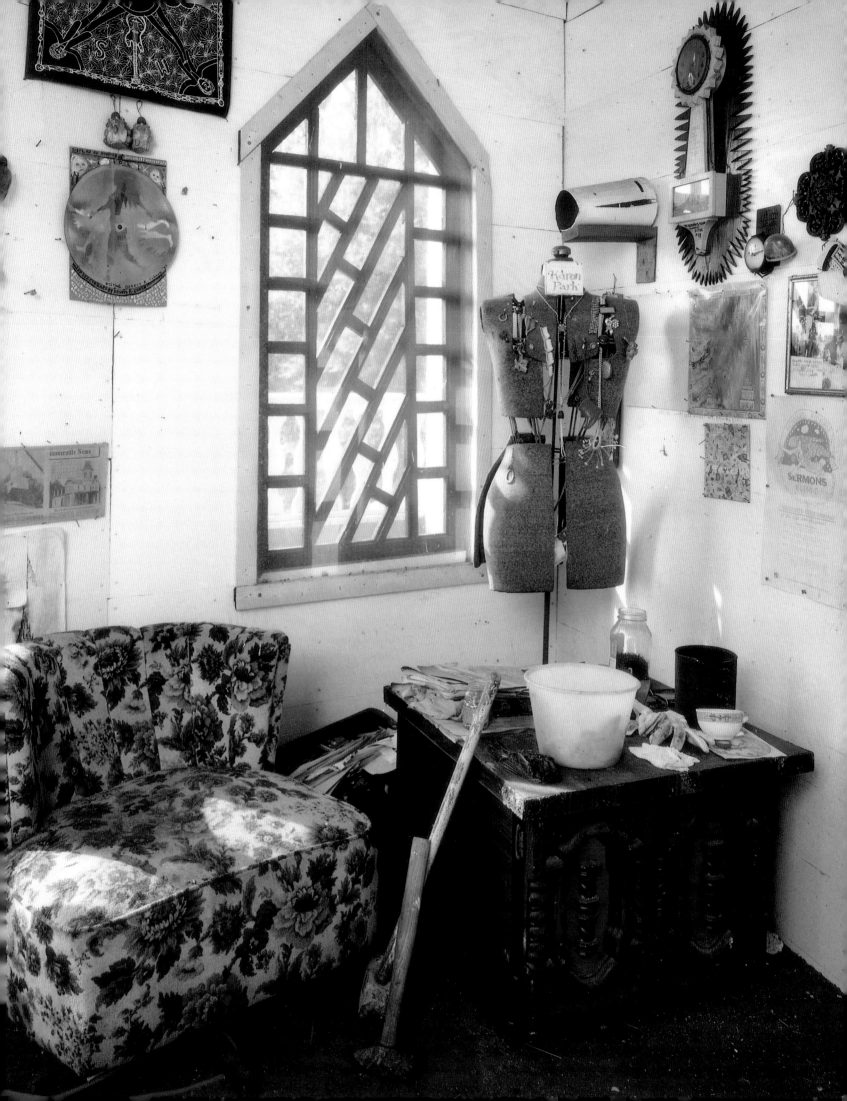

Past the Folk Art Chapel is a walkway leading down into the center of the garden. To the right, a pathway leads into a covered bridge set upon stilts that runs for several hundred yards above the garden, which is a shelter from the rain and an access way for the handicapped. On this route you can see the bicycle tower, a bulging structure composed of bicycle and lawn mower parts held together with wire. Farther along is the "Guardian Angel"— a large cut-out painting of an angel suspended between two poles with the names of Finster's friends and family and of historical figures covering the wings—and an enormous cement shoe standing several feet high (dropped into the garden by a giant, according to Finster). Then there is the penny sculpture, the guru of the garden: a five-foot-tall figurative statue made entirely out of pennies and cement that stands nobly next to an open mailbox containing a toy train.

In Paradise Garden the figures and construction are huge. The height of the bicycle tower is comparable to a two-story house. The enormous cement shoe is fit for a nursery rhyme. The chapel rises story upon story, almost reaching the clouds. Together, these structures with their exaggerated proportions lend Paradise Garden an otherworldly quality. Stepping into the garden one has the sensation of entering a fairy tale, a fantasy land created in the depths of an inspired imagination.

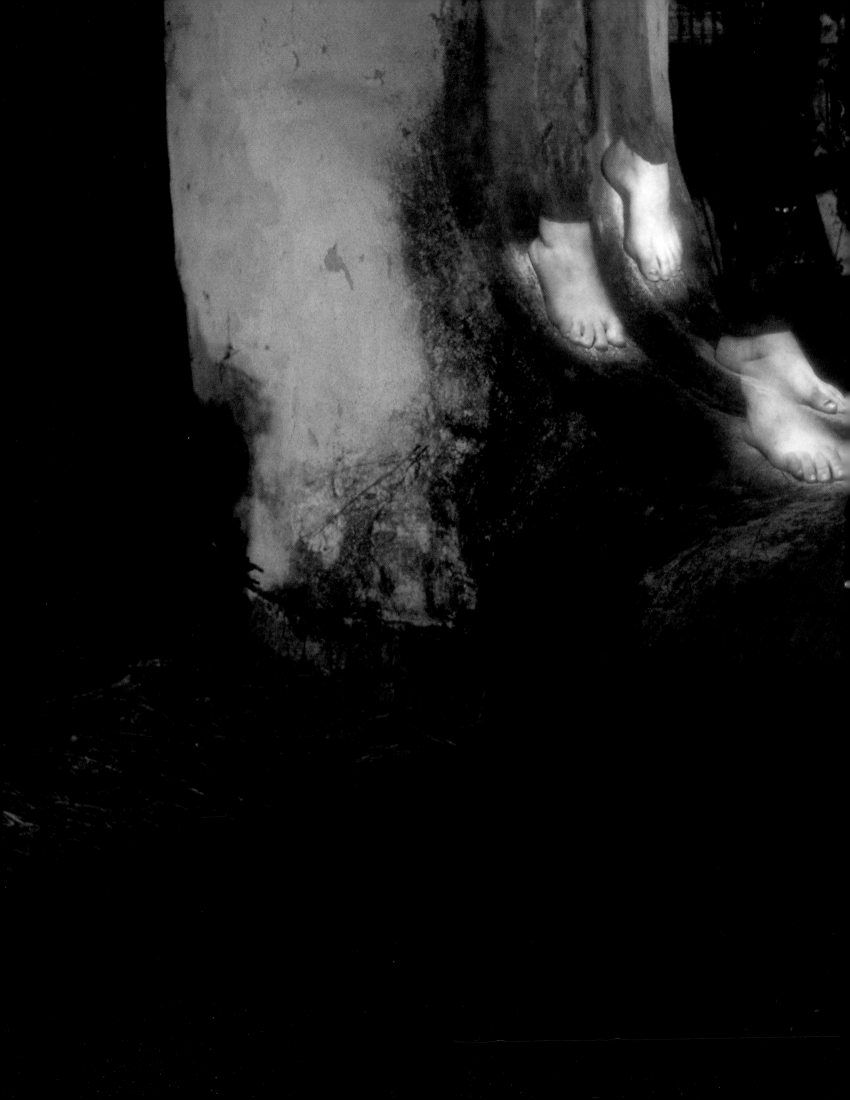

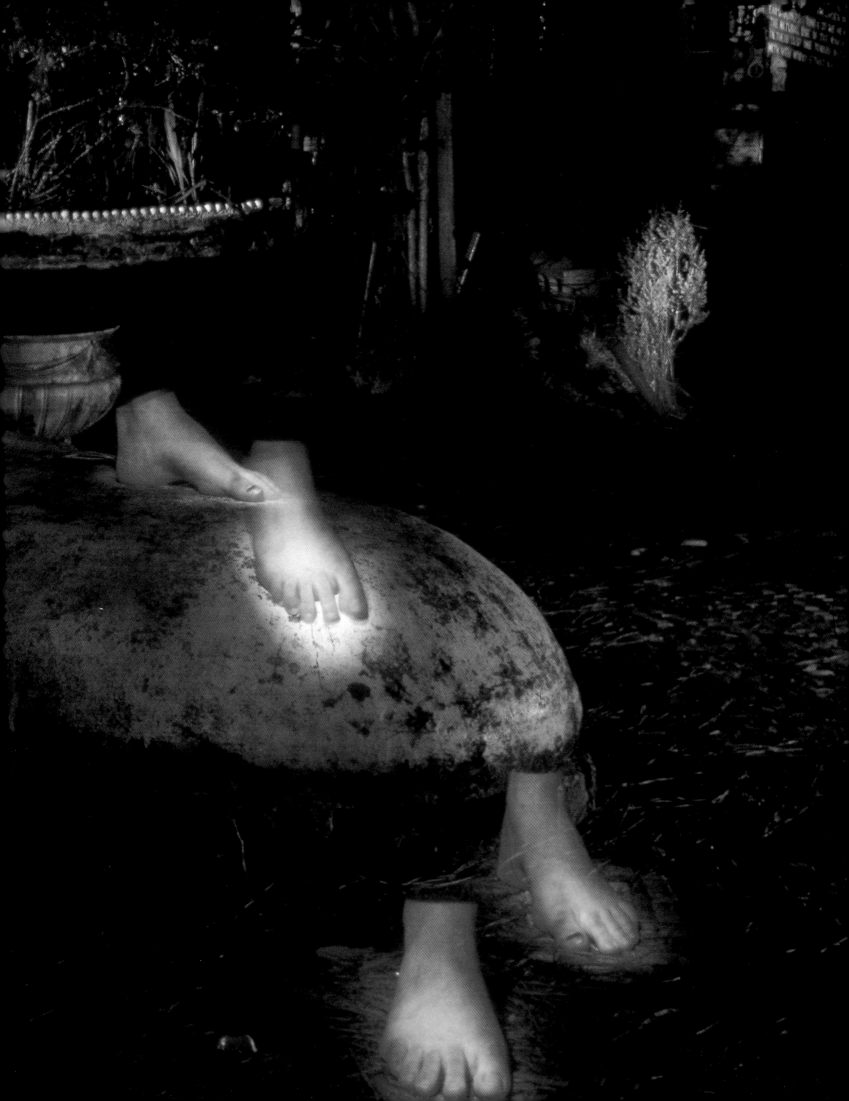

Finster calls himself "God's junk man," for nothing he comes across is too small or too broken to be discarded. Old machine parts, broken mirrors, used heart pumps, bus stop signs, and discarded pieces of metal and plastic toys are just a few of the many miscellaneous pieces that make up Paradise Garden. In Finster's hands, tin cans are cast and made into art objects. Stacked coke bottles form whole sides of structures. Wipe rags and paper napkins become mobiles. Refrigerator racks transform into bird cages. Discarded invitations to art openings, along with their ripped envelopes, cover various items. Ordinary objects become tactile wonders. There is a continual metamorphosis that takes place in Paradise Garden, as Finster never ceases building.

As a craftsman and mechanic Finster has built and repaired TVs, cars, bicycles; he has designed clocks, furniture, and buildings. The garden reflects all these skills. Here his collections, waiting to be transformed into art objects, become examples of the Southern gothic, undesigned examples of the gentle decay of cherished possessions: a car, once used for going to town, now tarnished by rain; the bottle house, meant to be a pump house, now empty and abandoned; a clothesline, with its parade of sheets and dish towels gone, stretched across a sign bearing the message of repentance.

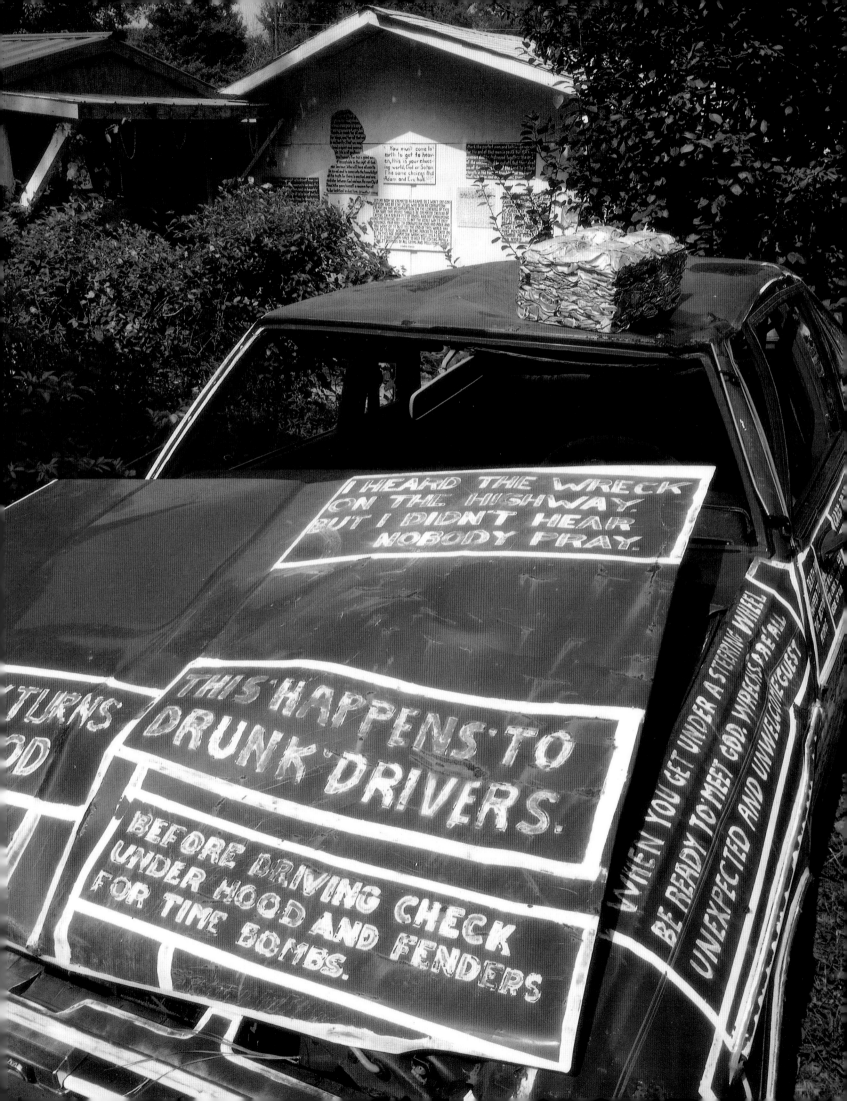

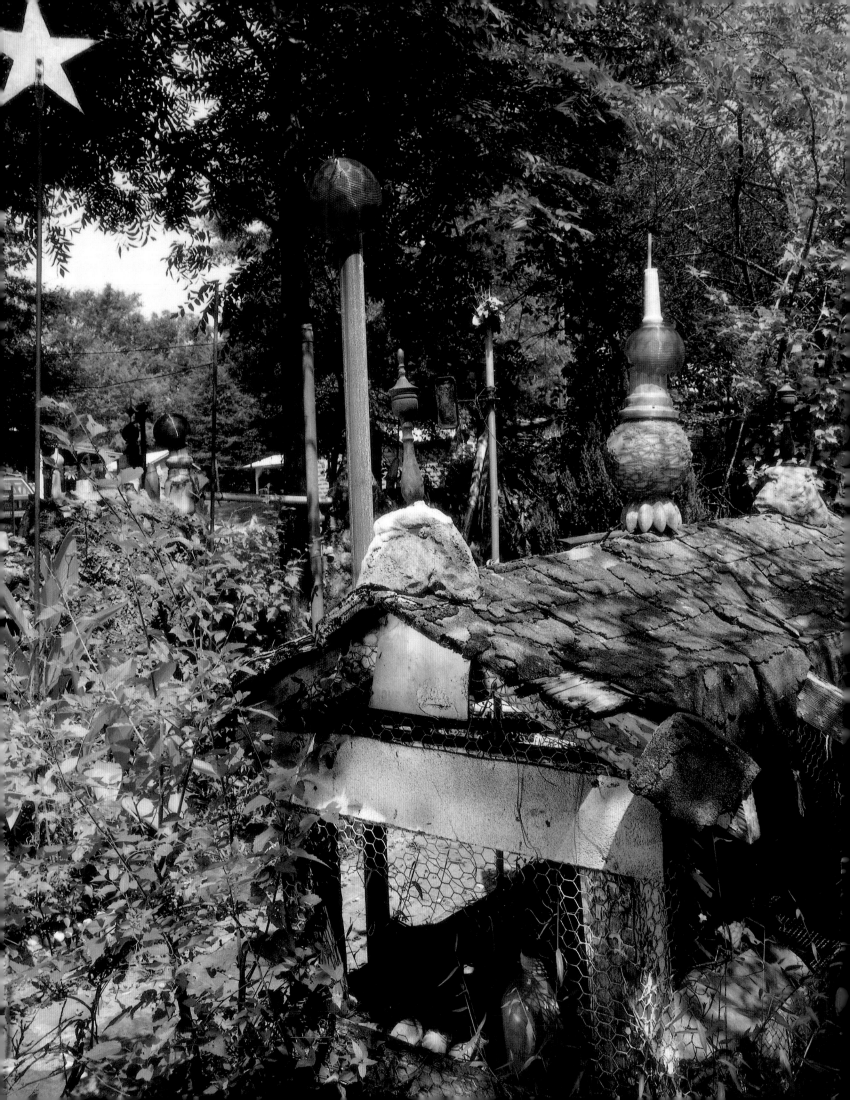

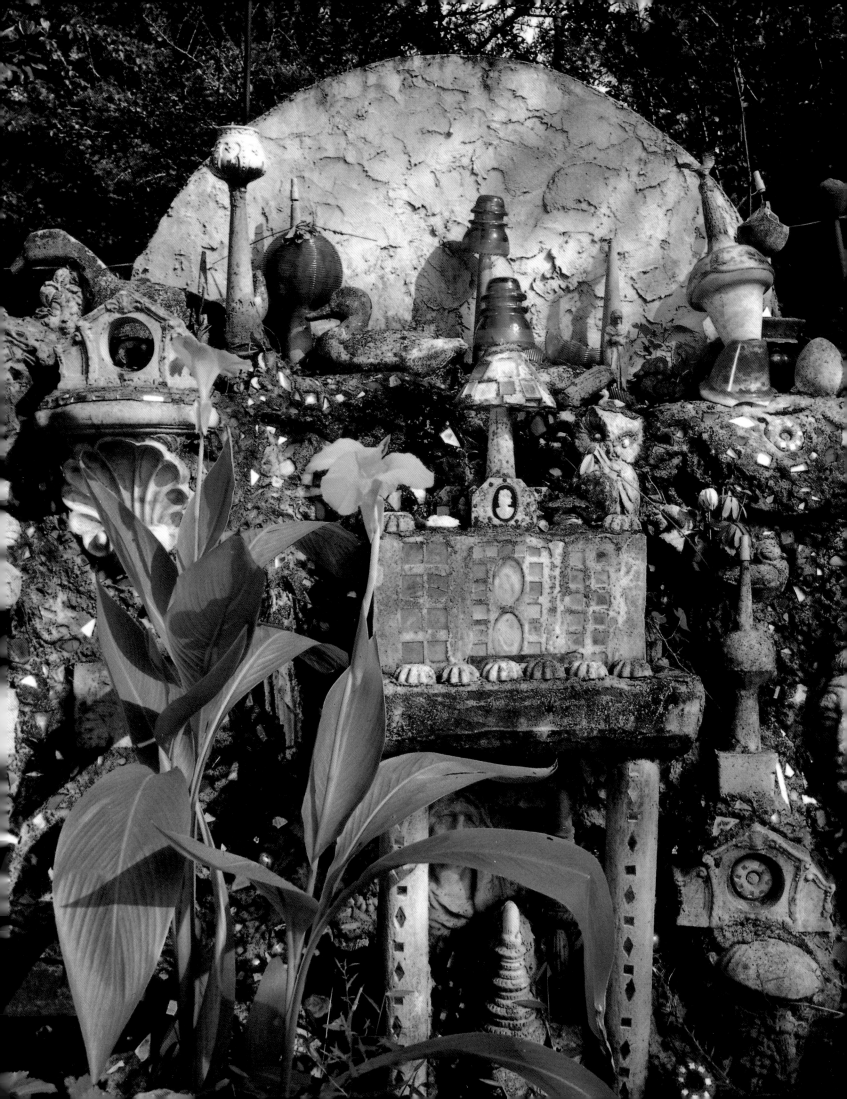

CAME'FROM. IN·A·VISION.

INVISIBLE SOUND IN THE.VOCAL'CORDS. INVISIBLE.
BREATH IN THE LUNGS. THIS IS THE INVISIBLE
SECOND ADAM FROM THE INVISIBLE.BREATH OF THE
INVISIBLE GOD. WHICH MAKES.US.A EMAGE OF GOD

L.E.MEMBE

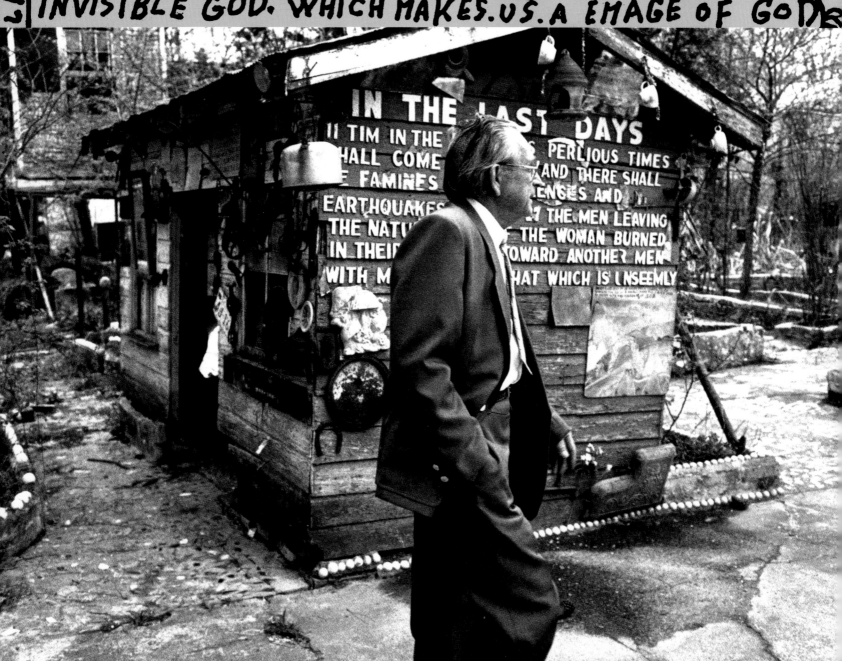

NO'SOUND. LUNGS.WITH NO'BREATH. THIS IS THE FIRST
ADAM. THEN: GOD'BREATHE'S.INTO THIS FIRST ADAM.
AND HIS INVISIBLE BREATH MAKES.A'INVISABLE'SECOND
ADAM. WHICH IS INVISIBLE FEELING.IN THE BODY.AND
INVISIBLE.MEMORY.IN THE BRAIN. INVISIBLE TASTE·IN
THE TONGUE. INVISIBLE SMELLING IN THE NOSE. AND

IS OF HUMAN BOD

FACTS. OF. WHERE. HUMAN

THE. FIRST AND SECOND ADAM. GOD MAKES. THE FIRST
ADAM. A BODY. WITH NO. FEELING. A BRAIN WITH - N O -
MEMORY. A TONGUE WITH NO TASTE EARS WITH NO
HEARING. NOSE WITH NO SMELLING. A VOCAL CORD WITH

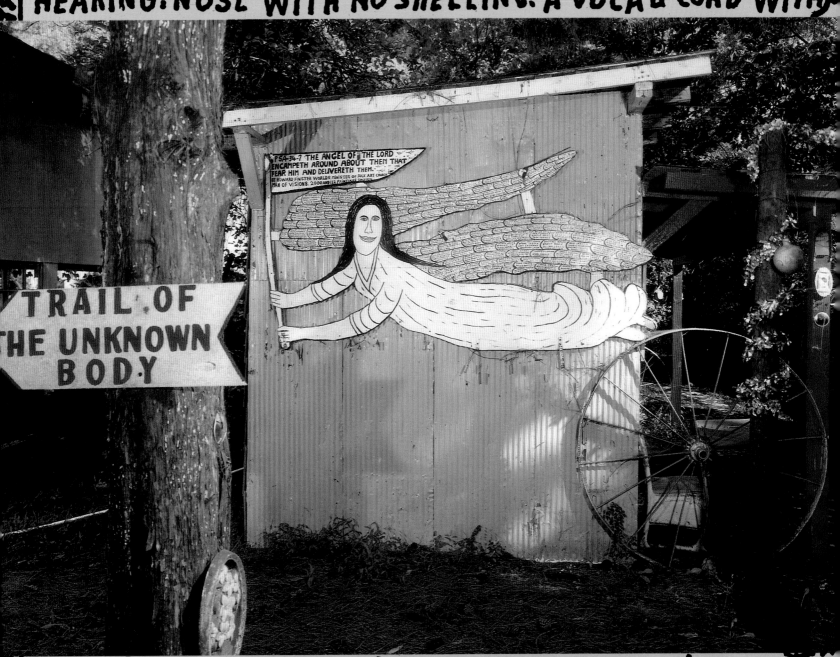

TRAIL. OF THE UNKNOWN BODY

MEMORY. A TONGUE WITH NO TASTE EARS WITH NO
HEARING. NOSE WITH NO SMELLING. A VOCAL CORD WITH
NO SOUND. LUNGS WITH NO BREATH. THIS IS THE FIRST
ADAM. THEN. GOD BREATHES. INTO THIS FIRST ADAM. —
AND HIS INVISIBLE BREATH MAKES. A INVISABLE SECOND
ADAM. WHICH IS INVISIBLE FEELING. IN THE BODY. AND

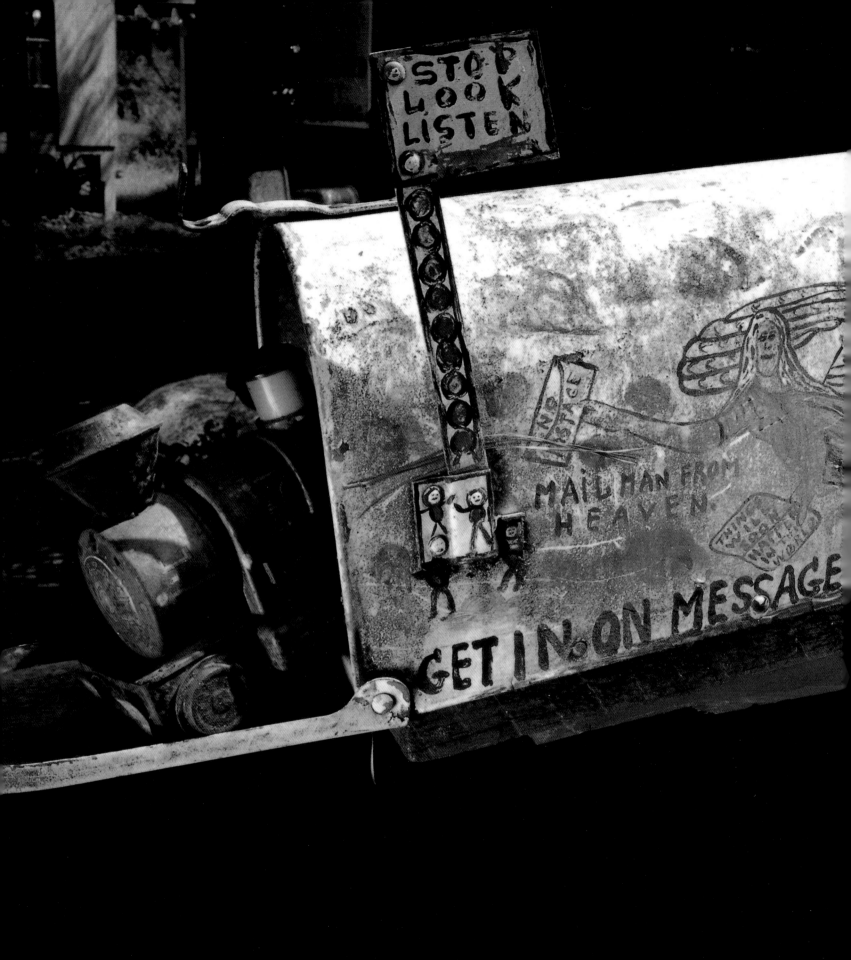

In a very real sense the garden has become the living evidence of Finster's inability to deal with time. He has no time to finish his garden schemes. The walks embedded with brightness stop and start; a great steel-mesh cross leans against a fence; a bridge designed to cross a little stream goes from one mud spot to another. Finster must choose daily between his two passions—his love of building and his painting— between creating work that stays in the garden and becomes a tarnished spectacle and work that carries his "message" out into the world beyond the garden.

Aside from the whimsical walkways, the statues, and the structures, the garden is full of Finster's paintings. They hang everywhere, ranging in size from five square feet to two square inches. Typically, they are cut out of wood with a jigsaw to form the outline of a figure. Some become real or whimsical beasts such as cheetahs, wolves, angels, and serpents. Others are made into human portraits, busts of famous historical figures, religious icons, or Finster's friends. Shakespeare and John the Baptist have places in the garden, as do Elvis Presley, Henry Ford, and John F. Kennedy. On one wall of the Folk Art Church sits a plaque with four closely grouped heads: Ulysses S. Grant, Henry Ford, Theodore Roosevelt, and Harry S. Truman; underneath it, a question: "What are you doing to save this old world?"

TRYING TO GET PEOPLE BACK
TO GOD BEFORE THE END OF
EARTHS PLANET GOD WILL NOT
 ALLWAYS STRIVE

Printed words can be found in every nook and cranny of the garden, encased in the sides of a building, applied directly onto the structures themselves. Calling himself "God's red light," Finster boasts that the garden has "literally been covered up with Bible verses all over it, where a minister can come in here and bring a sinner and take him round and read him into the Kingdom of God." Indeed, every one of the thousands of paintings has a message written on it. And the message is always the same, though it gets phrased in infinite ways: turn away from Satan and his evil and turn toward Jesus and the way of the Cross. Though the phrasing may vary from sign to sign, the expression is always dramatic, clear, and insistent. One such message situated on a plaque to the side of a walkway reads:

The wages of sin is death, but the gift of God

is eternal Life. It is time for all mankind to make

their choice of life or death. Life is eternal and

full of glory. A walk down the golden streets

is really the choice to make. Don't miss heaven.

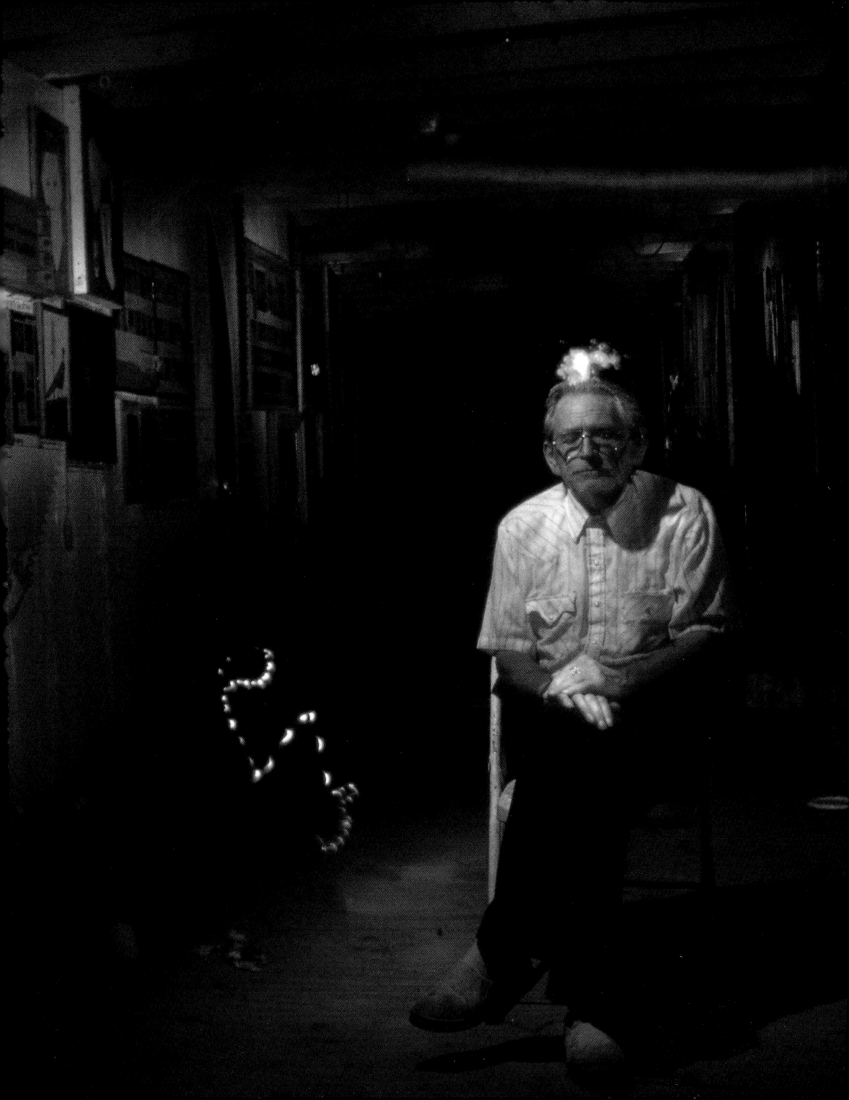

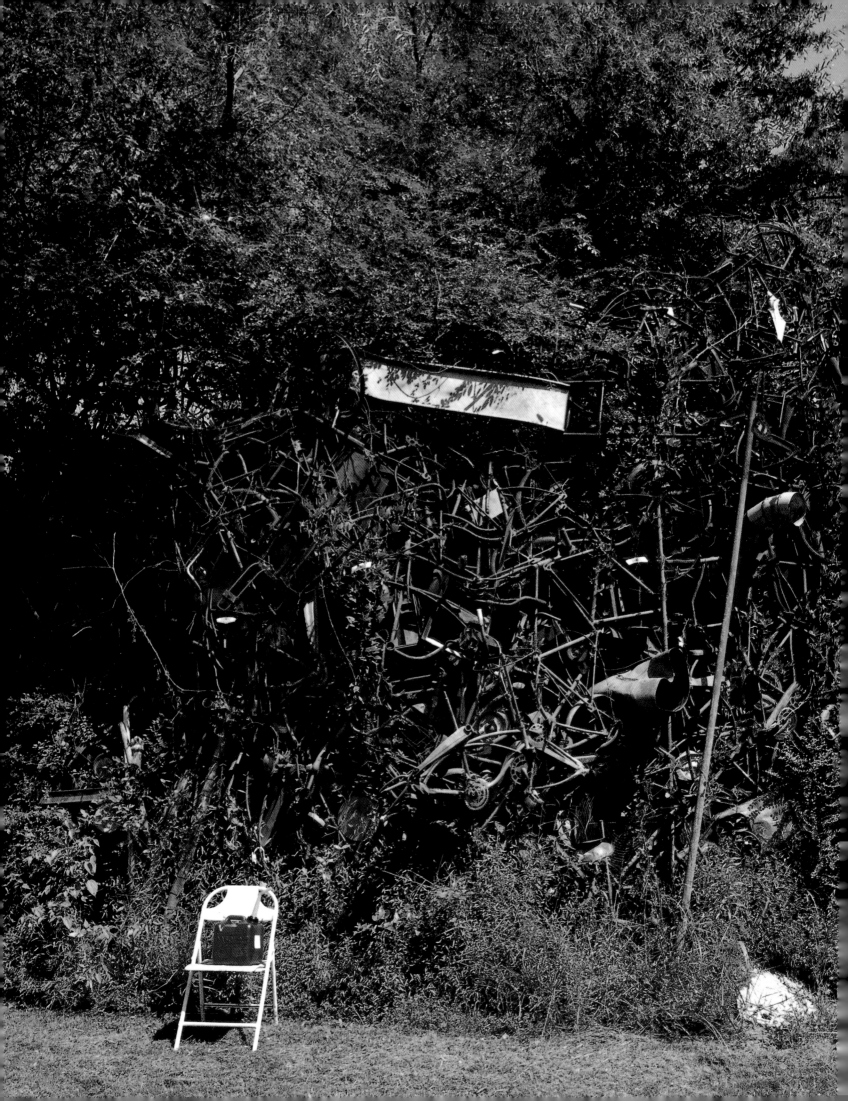

Whatever the garden presents to the visitor—pleasure, amusement, wonder—these messages are the most important to Finster. They are messages of salvation and reflect his calling to spread the word of God. It is to this calling that Finster has devoted his life and work, ever since the age of sixteen when he began his life as a reverend. Finster's work as an artist is merely a by-product of his mission to serve God. Finster first conceived of the garden through an inspired vision. Then in 1961, he purchased a city-block-sized plot of land for a thousand dollars on which to construct this vision of Eden. He didn't have any materials nor any money to buy them. Using collections of his own works, as well as found objects like Indian arrowheads, Finster set out gathering pieces from dumps and amassing things people had thrown out. He'd watch to see when a barn or a building was being torn down, and before the ruins were hauled away, he'd take old lumber and whatever else he might find. Whatever he came away with he'd either use for his own buildings or work into the garden somehow. Little by little Paradise Garden emerged. As Finster worked and saved enough to buy materials, the garden blossomed with new buildings and monuments.

In 1976, years after work on Paradise Garden had begun, Finster received a vision that told him to put away all other things and devote his life solely to creating sacred art, art that would cover the world over with the word of God. To embark upon this calling Finster embedded his bicycle repair tools in a stretch of sidewalk as a symbol of this new commitment. Paradise Garden is Finster's most important work, and it is here that evidence of Finster's commitment and beliefs is most evident. As God has given freely of his great mercy and love, so Finster offers Paradise Garden, with its signs and paintings of praise, as a special space for offering hope for the lost and confirmation for believers in the ways of God and salvation.

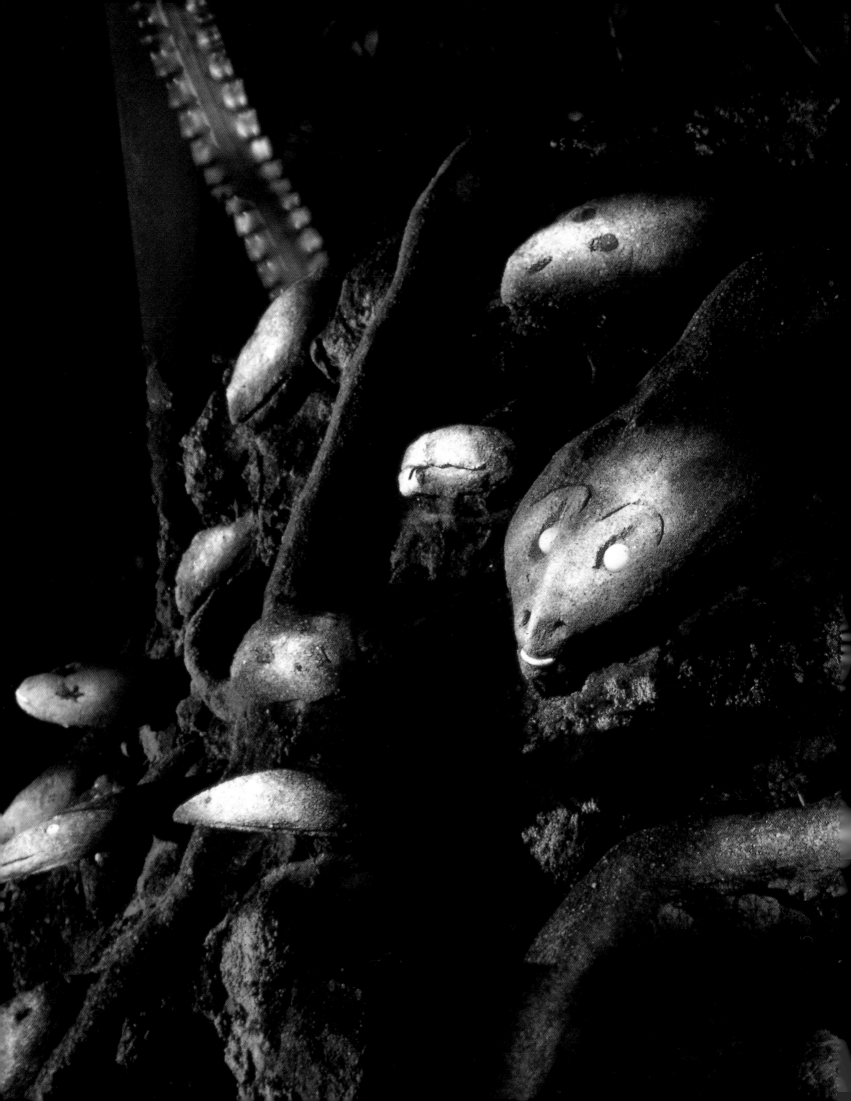

When one walks through the garden, an incandescent presence is felt; a stark, eerie beauty infuses Finster's creation.

And the more time spent there, the stronger and more apparent this presence becomes. A strong energy exists there, one that can be viewed, experienced, and in a deeper sense drawn upon.

Finster exists in two worlds, one of flesh and blood—our earthly world of telephones, automobiles, and television news—and a mystical world in which religious visions determine the only boundaries. By not spending too much time in either, Finster is prevented from being consumed by one or the other. Ordained by the truth of his intentions, he has come to experience free access to both worlds. In a sense, the garden can be viewed as a kind of crossroads or monument marking the presence of these two worlds, realizing even if only temporarily a union of the mystic and the corporeal.

The Bible House

I call this the Bible House. I cut lit-
tle letters out of masonry because I
didn't have much time, and I nailed
them on the wall. They have stayed
there better than any letters I've
ever done. That little picture down
there, on the corner, shows a camel
going through the eye of a needle.
The camel has to get down on its
knees to get through the eye of the
needle. It's in Europe. Jesus said,
"It is easier for a rich man to get to
heaven than for a camel to get
through the eye of a needle." That
means that the rich man has to
humble down before he gets saved.
It was built about twenty-four years
ago. Now it's about gone.

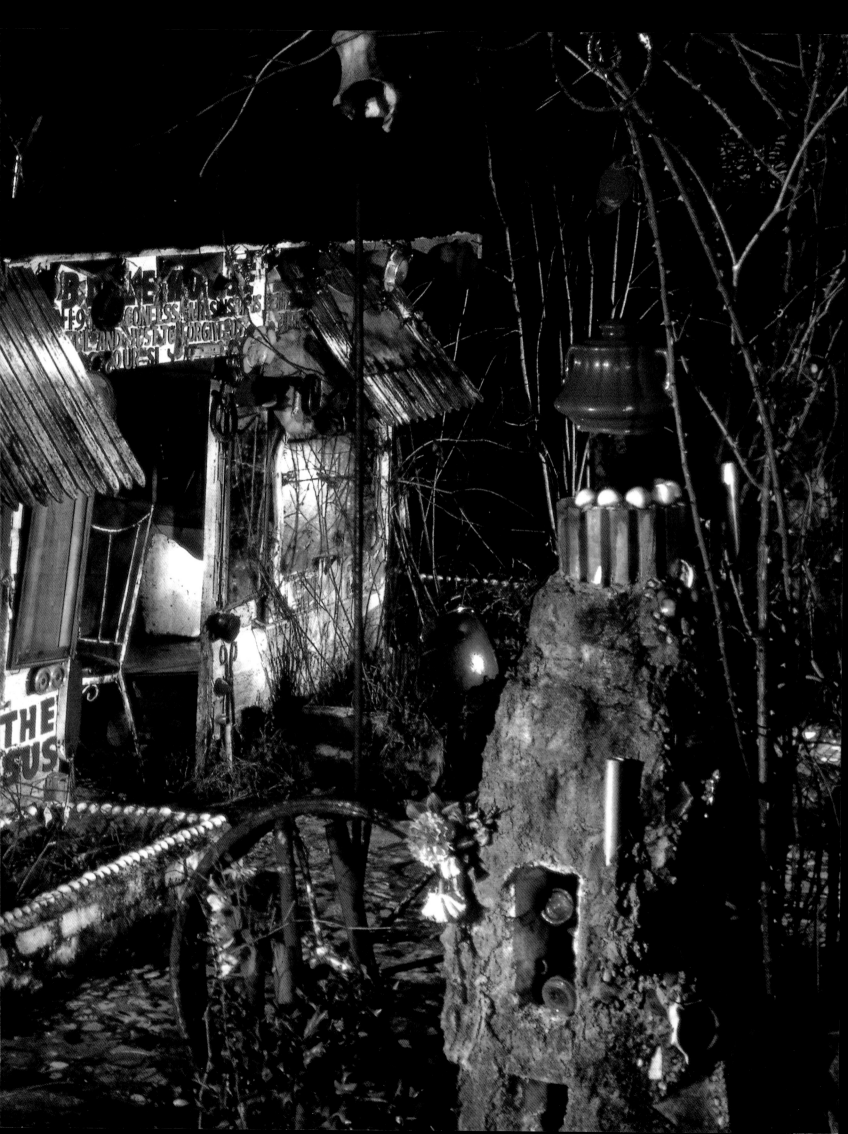

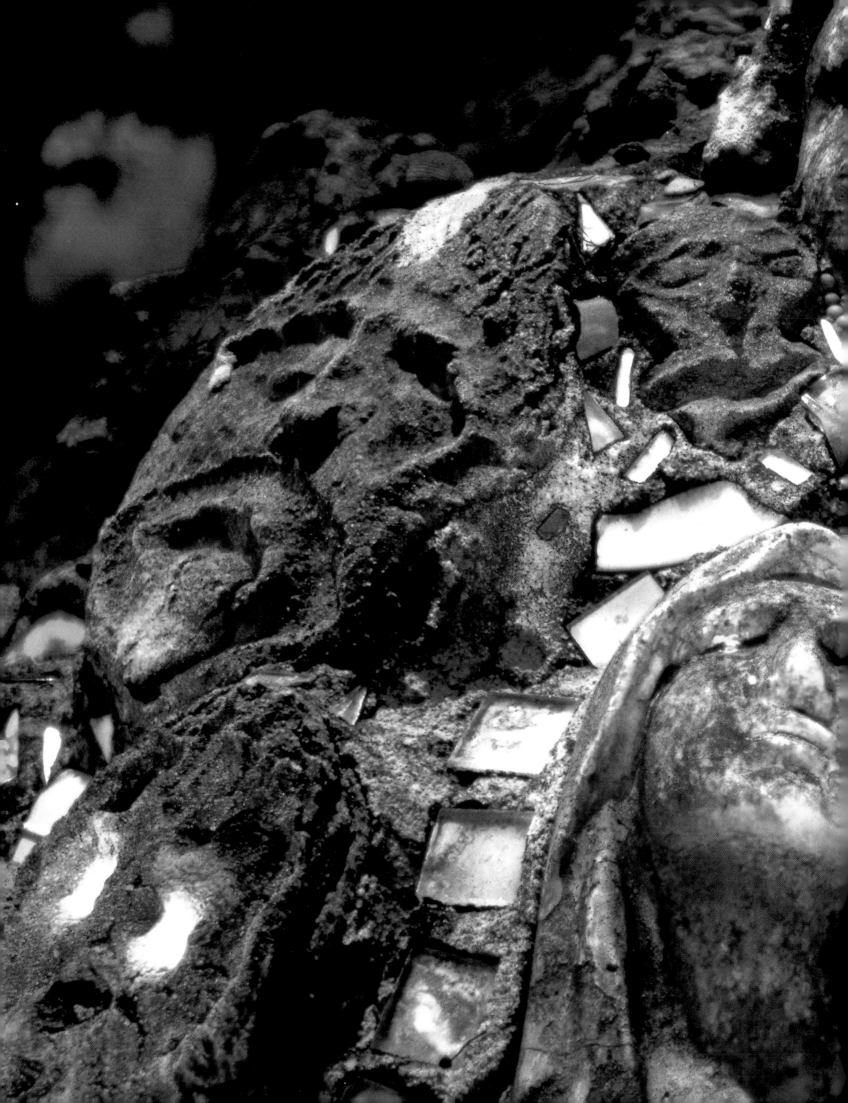

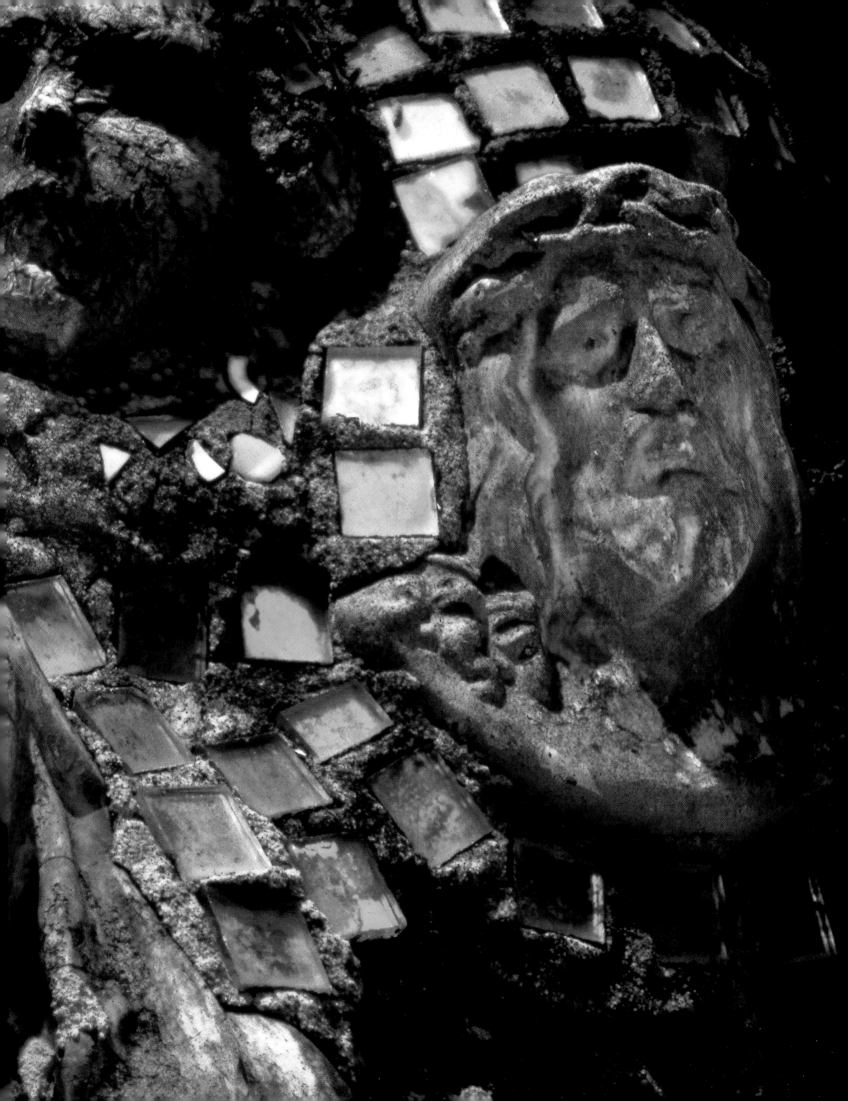

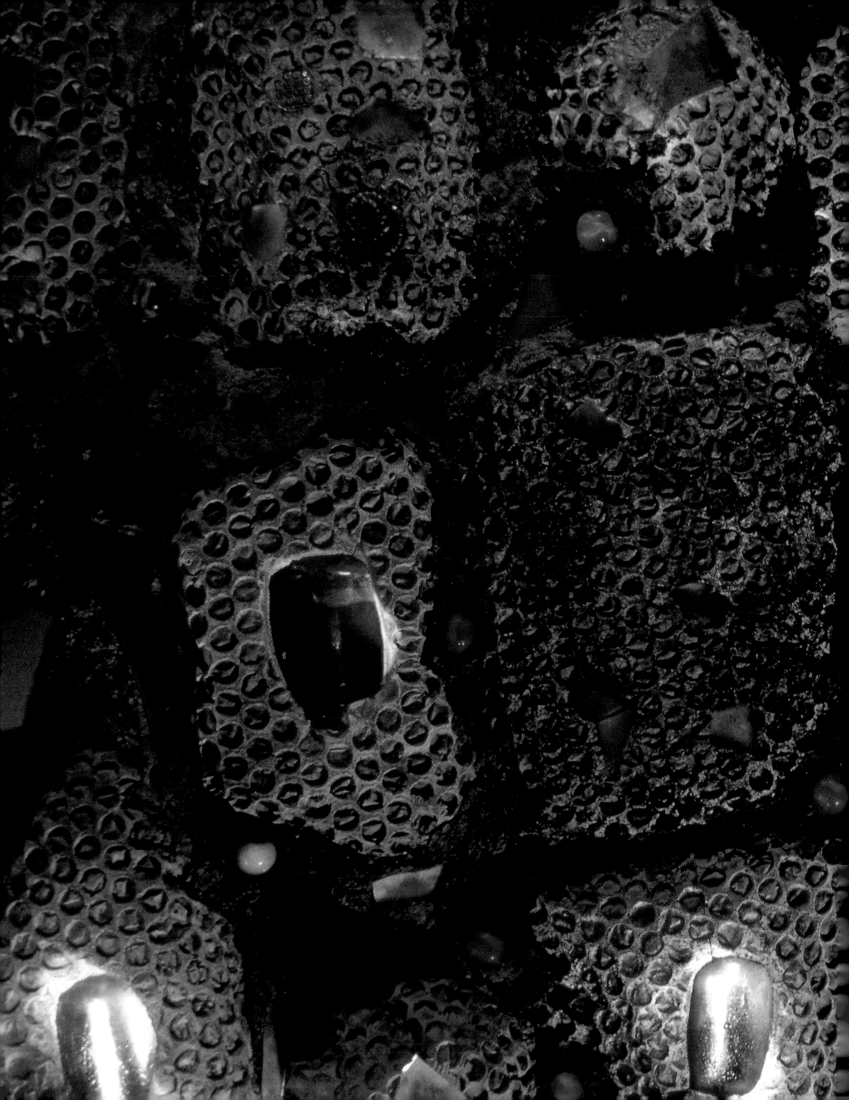

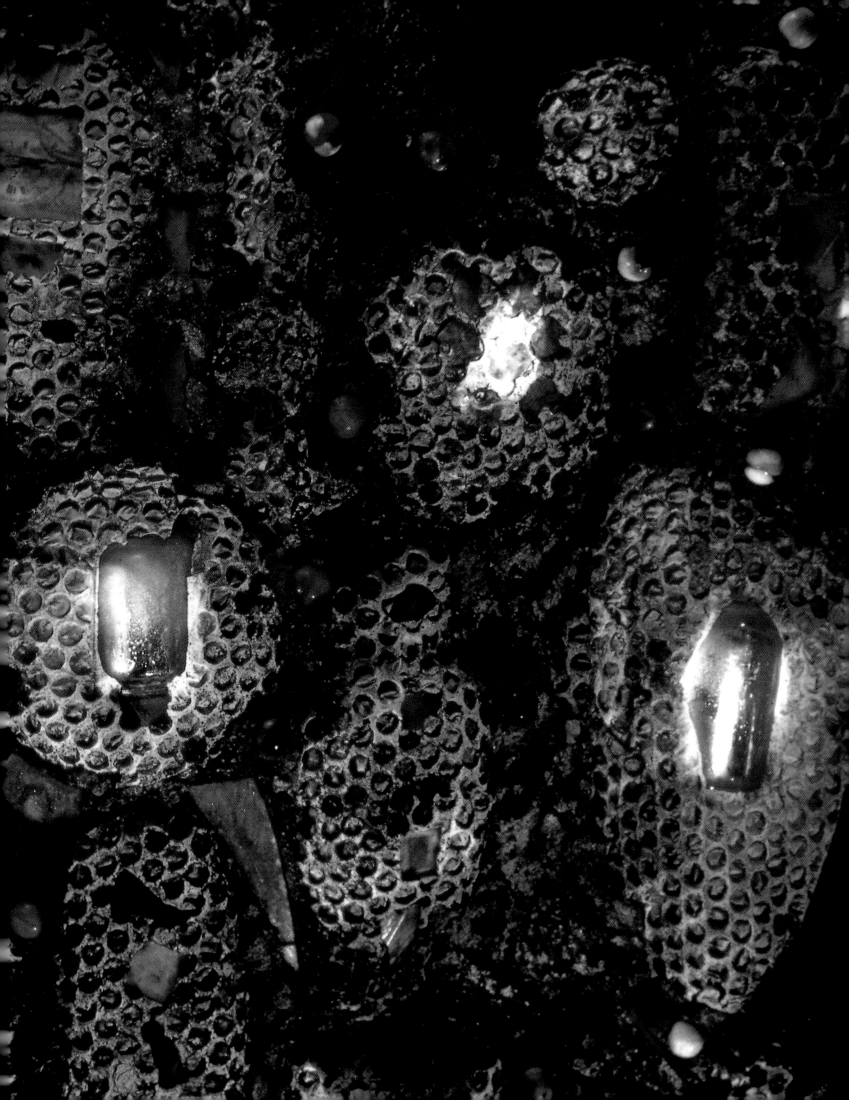

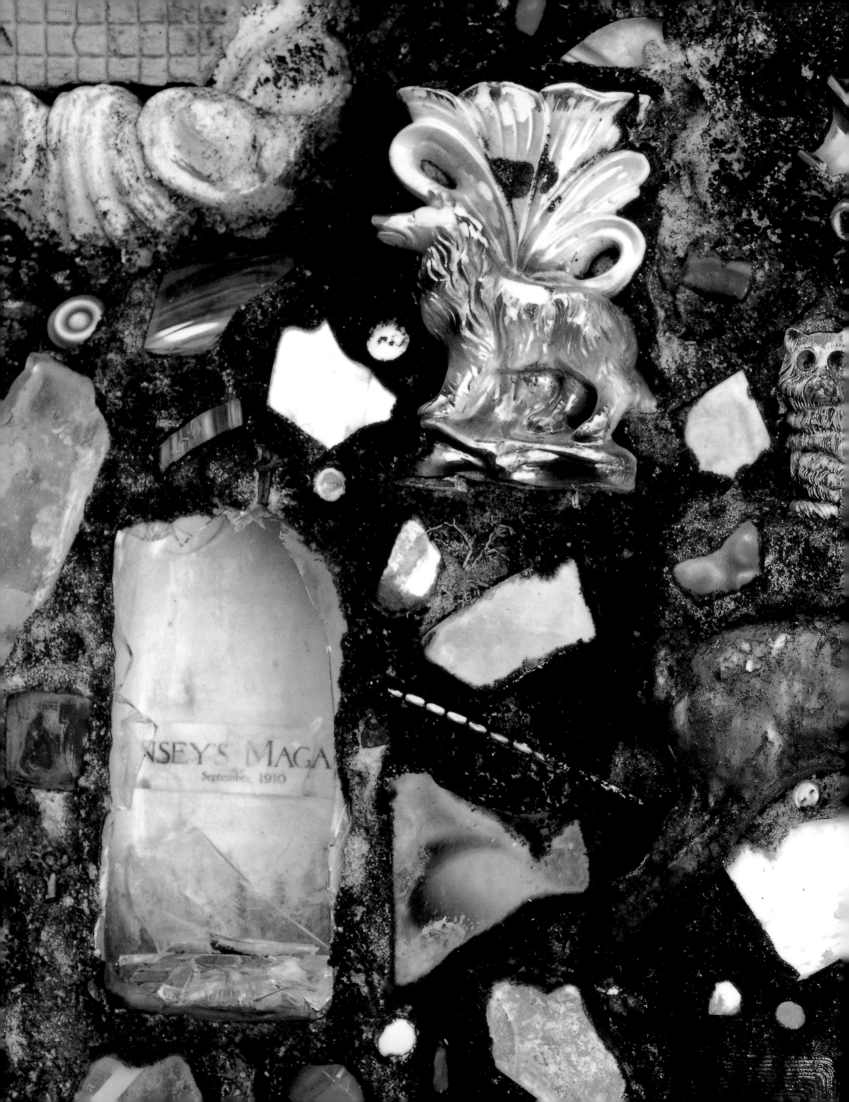

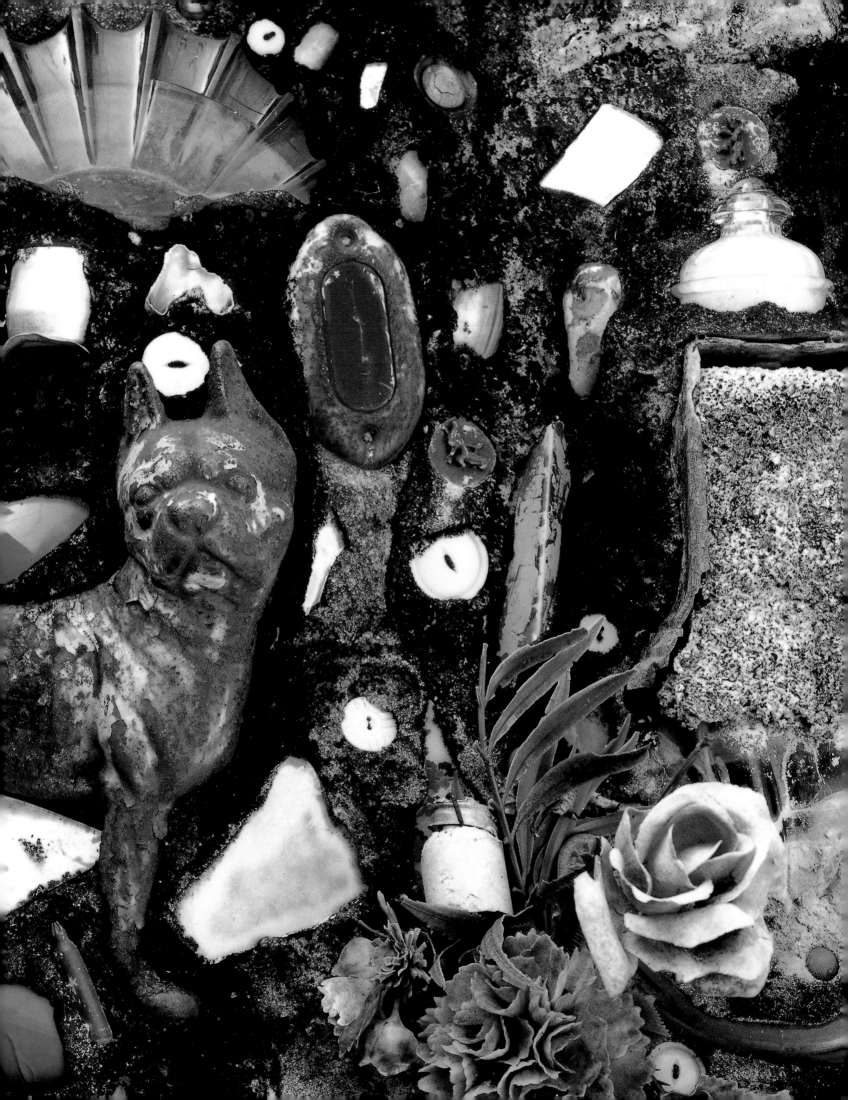

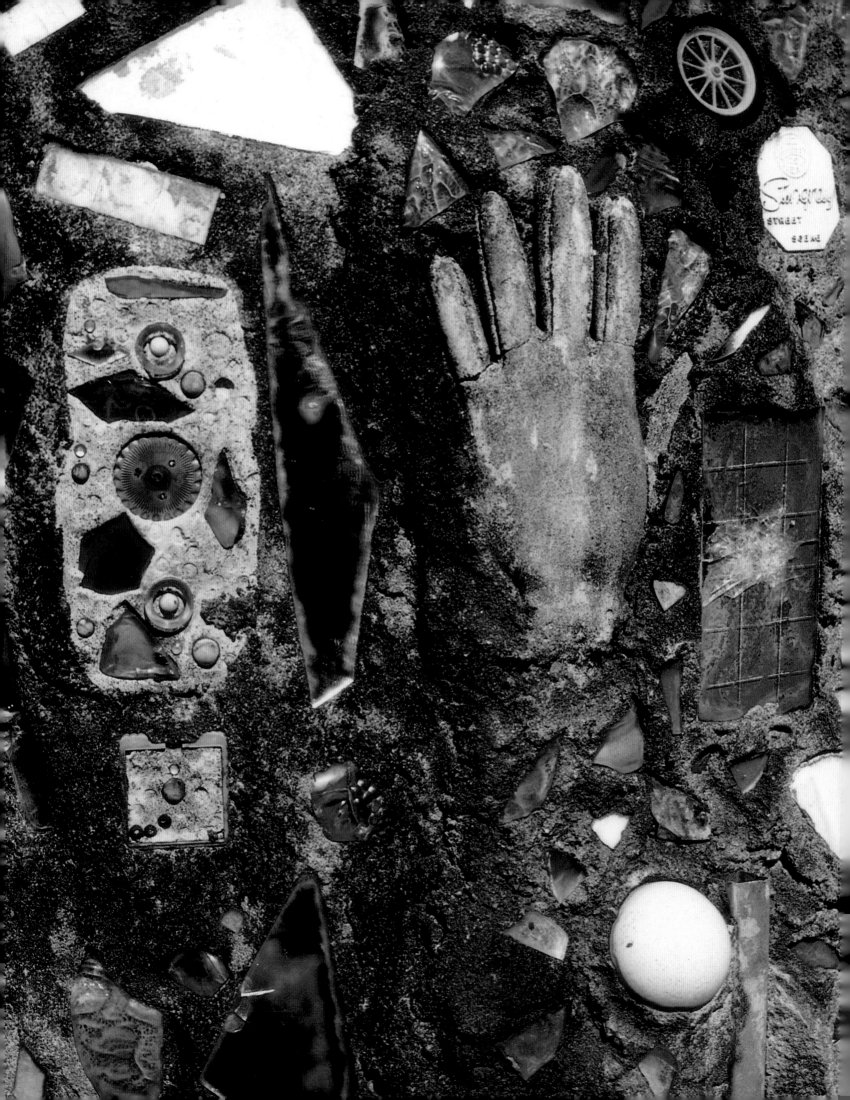

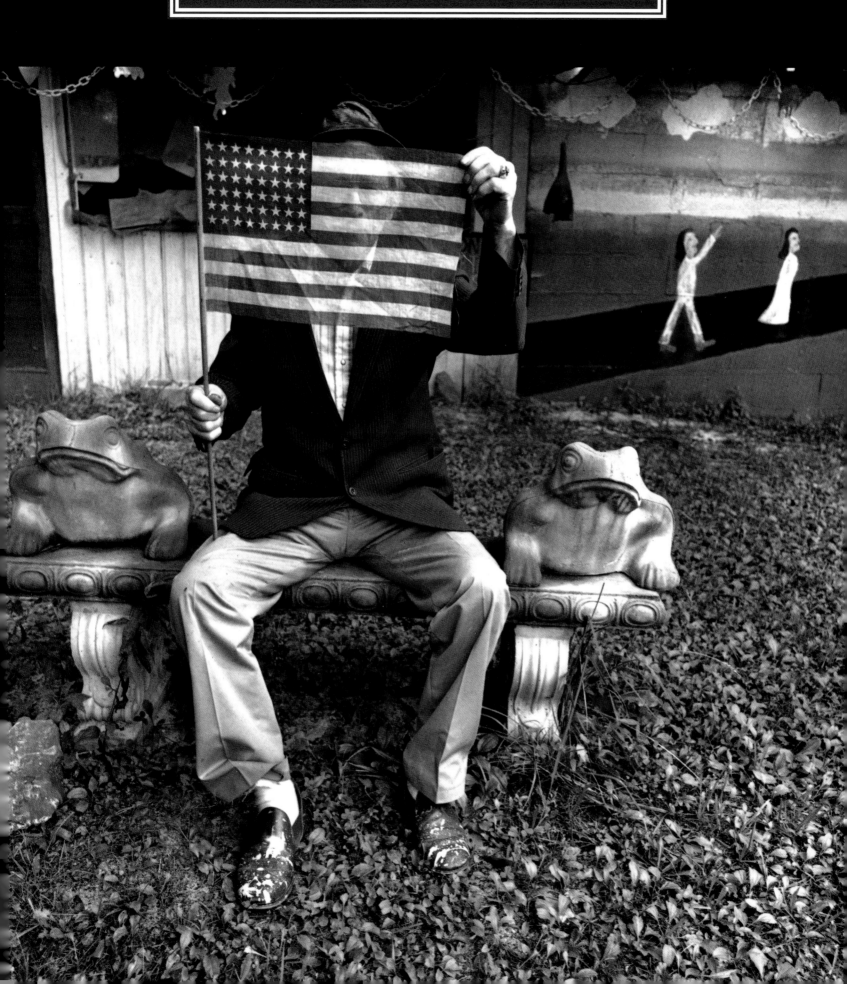

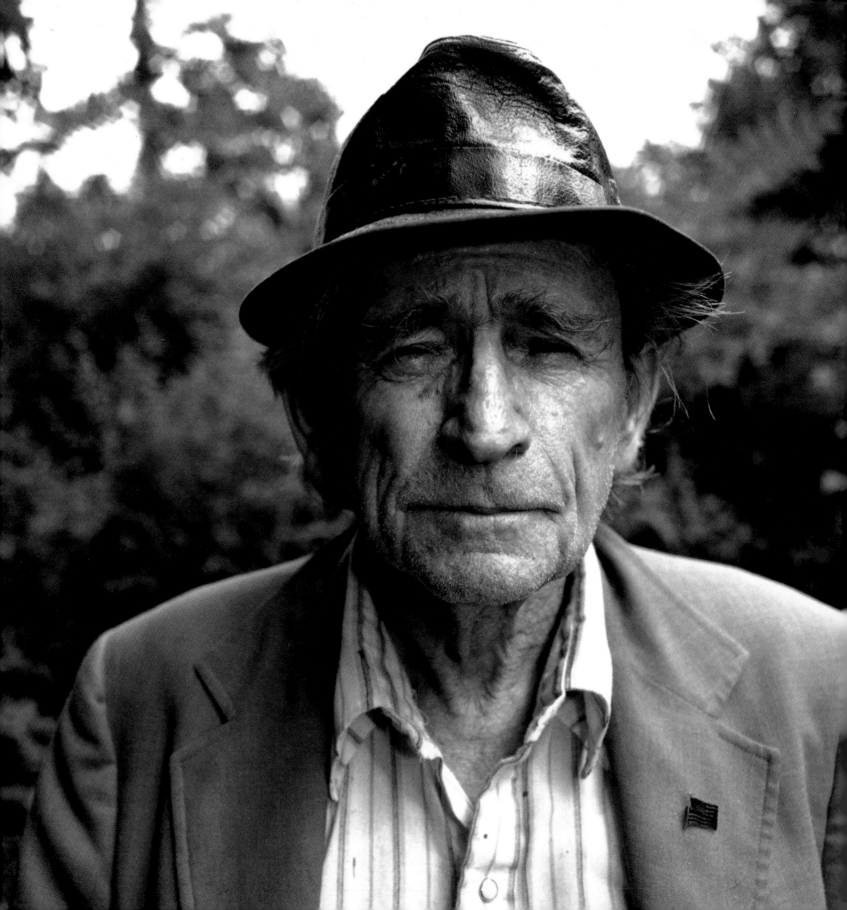

This is Howard Finster here. People ask, "Who is Howard Finster?" Well, I've heard about Howard Finster. I go to New York, there is Howard Finster. I go to Miami, Florida, there is a feller, his agent, down there. I go to Los Angeles, there's people knows him there. **So who is Howard Finster?** Well, that is what I'd like to tell you, right now, if you have time to pick the dust out of your ears and listen. **I can tell you who Howard Finster is better than anybody in this world can tell you who Howard Finster is.**

Howard Finster is a man like this. I'll be seventy-nine years old December 2, and I've never had a traffic ticket, and I have drove all across the country. I have never been drunk, never had a wreck, never been arrested and put in jail. I've never stole anybody's stuff. I've never stepped out on my wife in my life. I play the banjo. That's who Howard Finster is. Since I've growed up and become a businessman, I've paid every debt I owed. That is who Howard Finster is.

I pastored churches, at the same time building bicycles for poor people, at the same time building clocks and selling them to live on, buying land to put this garden on—that is who Howard Finster is. I got down on my knees and fixed lawn mowers. I could put my hand on the spark plug and give it a jerk and could tell you if there was enough electricity to run the thing. I also learned a lot about my body. I had visions looking into my body, seeing how my lungs is, seeing how my stomach is, seeing how my brain is. Seeing how everything is. I am a man of vision. That's who Howard Finster is.

Howard Finster is a second Noah to reach the world before it is too late. In a way, I am having more success than Noah had. He preached to the world, but he didn't get a one of them saved. All he got saved as far as I know was his family. So I'm the second Noah, and I am leading my family to God. I am leading the world to God. People are getting saved today, 'cause they are writing and telling me, "Howard Finster, we seen your work and heard you out. We've found a way of life. We are living happy now."

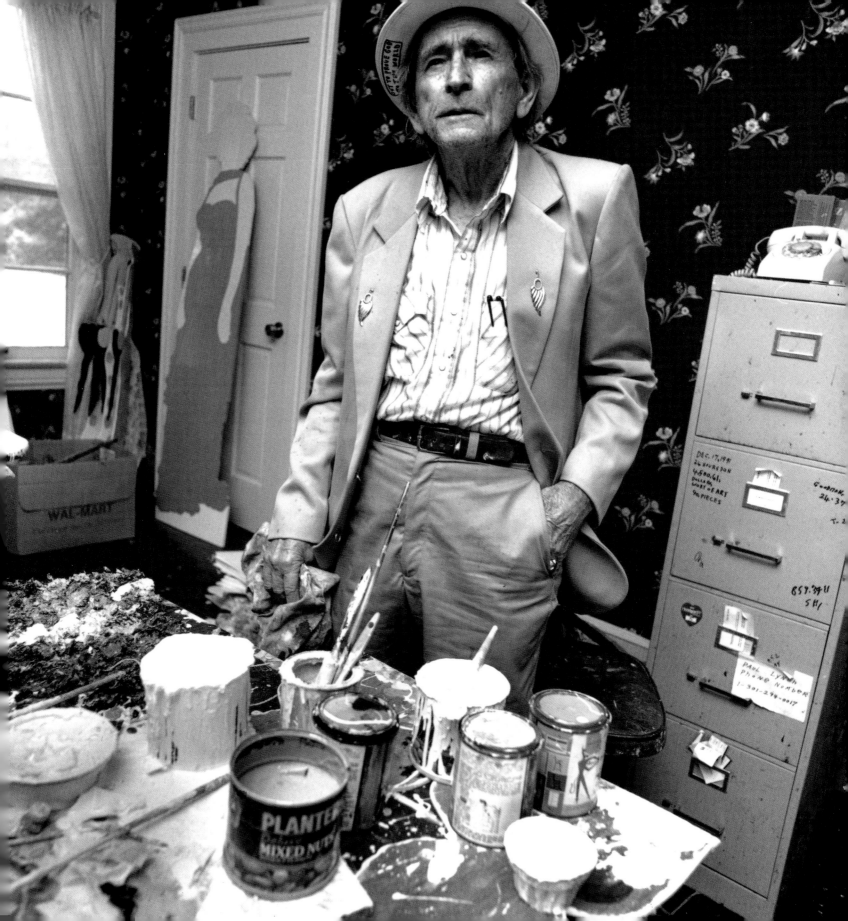

There is something in the reckless abandon of Howard Finster's work that stirs us all. It seems to exemplify the necessity to act above all else. The incredible profusion of found objects and their obsessive accumulation into this fabricated Garden of Eden is, indeed, powerful. Standing in the middle of it all, one can't help but feel that he who hesitates is lost. Here in the outskirts of Atlanta, there is a touching glimpse into an aspect of the human psyche that seems obliterated by the reigning culture of education and the media. One single person, struck by a vision, was not deterred from what had to be done.

Sandy Skoglund, photographer

Howard Finster is from God. Howard Finster has a gift from God. Like I tell everyone, I do not have ideas, I have visions. I had a vision for a garden thirty-five to forty years ago. I had a feeling for a garden—a garden where people could go in and feel free and stay a day or two and not have to worry about spending what little they had made or saved up for a vacation. My garden, and my art that goes into the garden, is all free. Nobody pays a dime here to make a story; nobody pays a dime to eat anything that's in this garden. Nobody pays a dime to put up a little tent. It costs nobody nothing to walk into the chapel and drink cold water and use my facilities. And most of the time I try to have a few Coca-Colas for anybody who wants a drink, or maybe a little cookie or something.

I was taken to visit Paradise Garden in 1978, and it was probably the most exciting, beautiful, satisfying work of art I have ever seen. Howard Finster had rechanneled a little river that went down through the garden, and he had built a mirrored house that he set on top of the river, and the ceiling, the walls, and the floor of the house were mirrored. He had installed a mirrored waterwheel, and the current moved the waterwheel—just the most extraordinary thing in the whole world. There was a pile of bicycles that must have been fifty feet high, and he had constructed and piled them so that you could walk inside under the pile and go around the interior perimeter and look out to the world at large, and what then you saw made was a world that was different than I had ever seen before. It was incredible, absolutely incredible.

Robert Bishop, late Director of the Museum of American Folk Art, New York

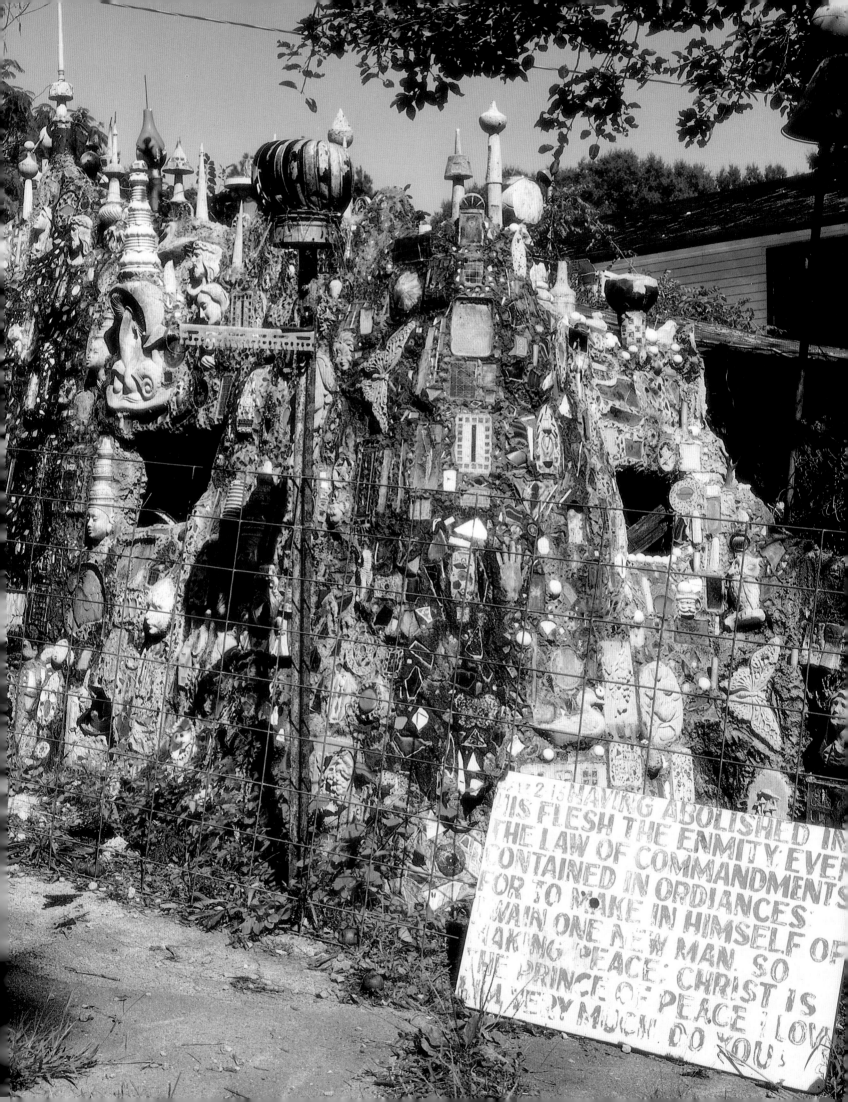

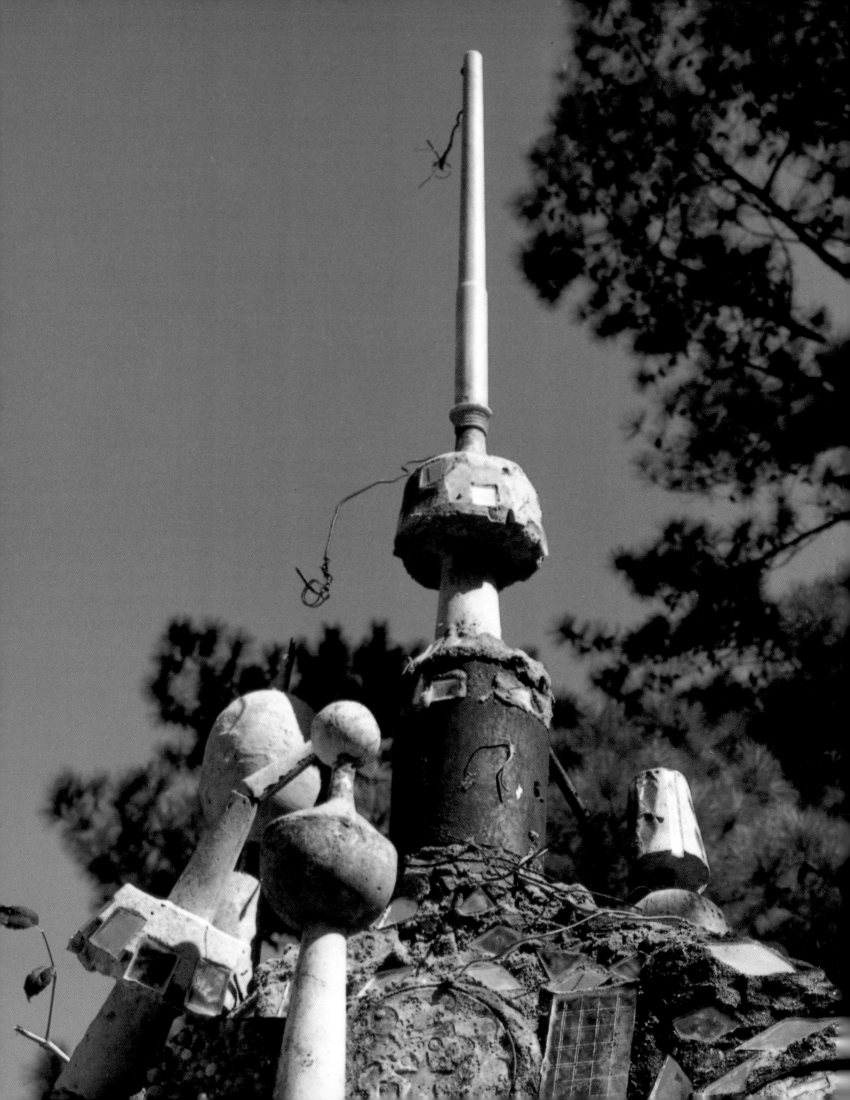

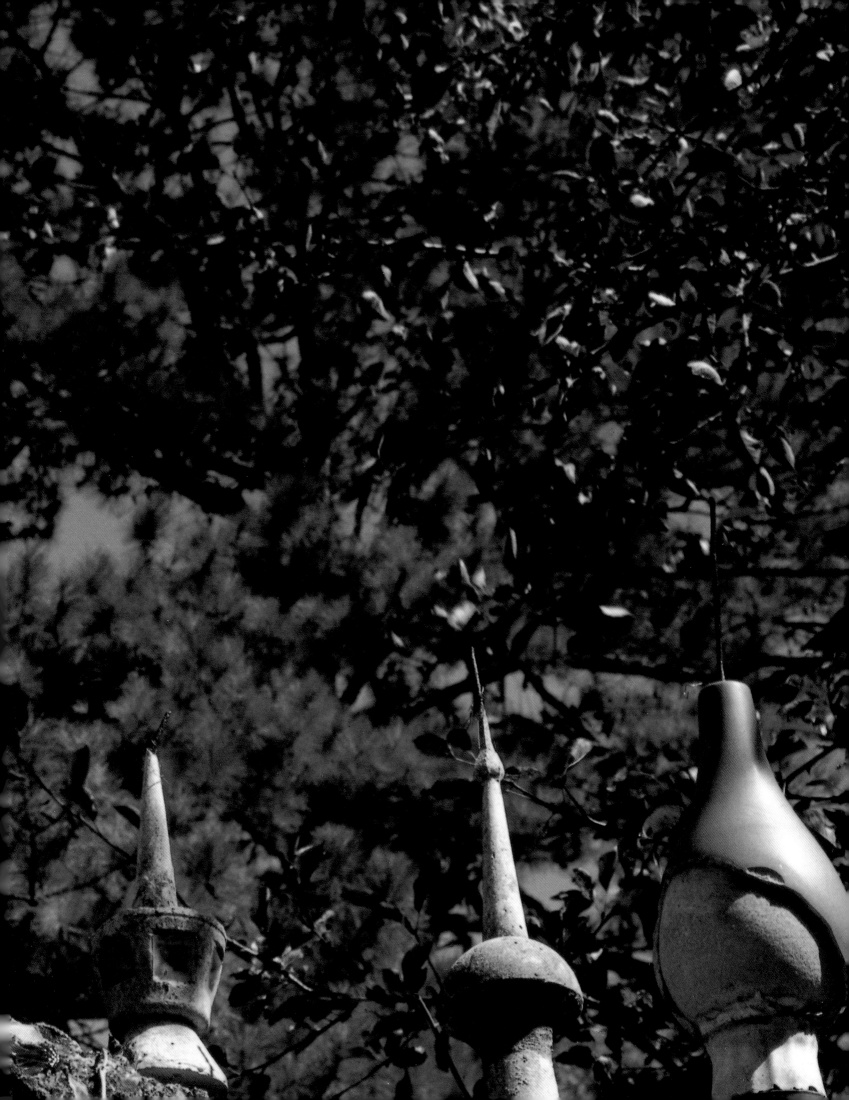

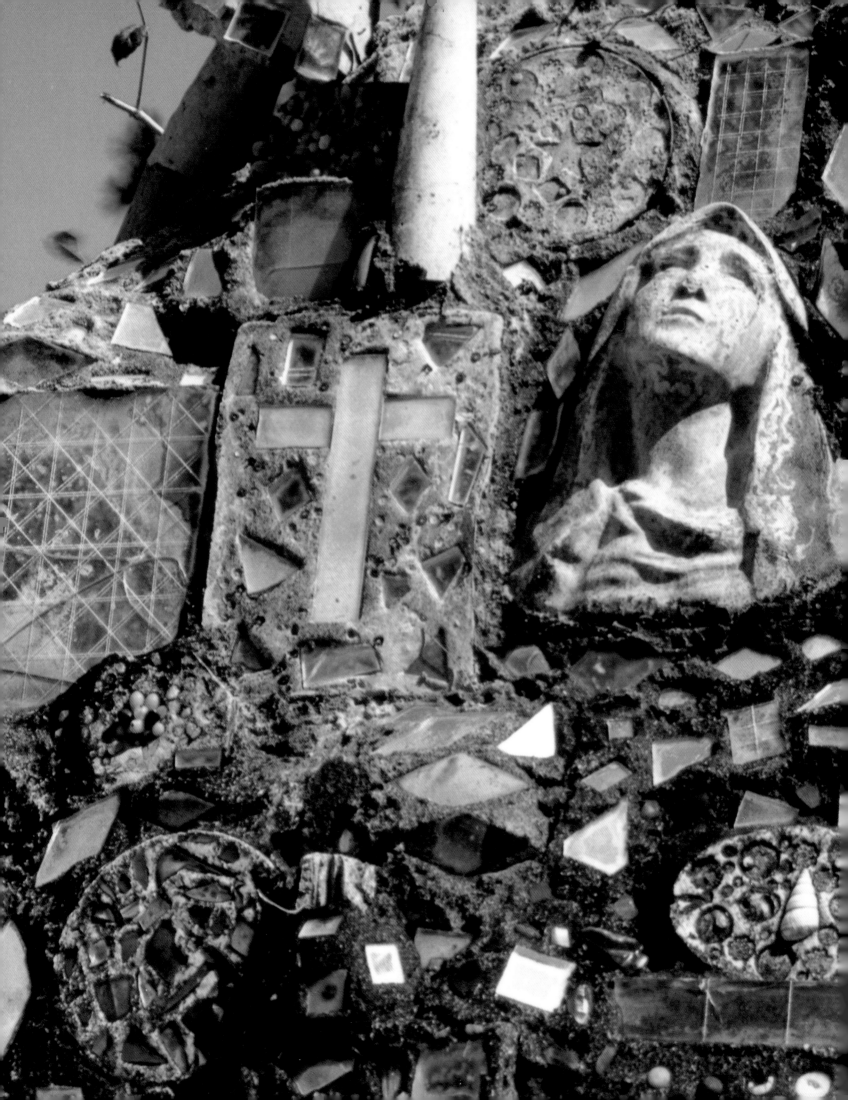

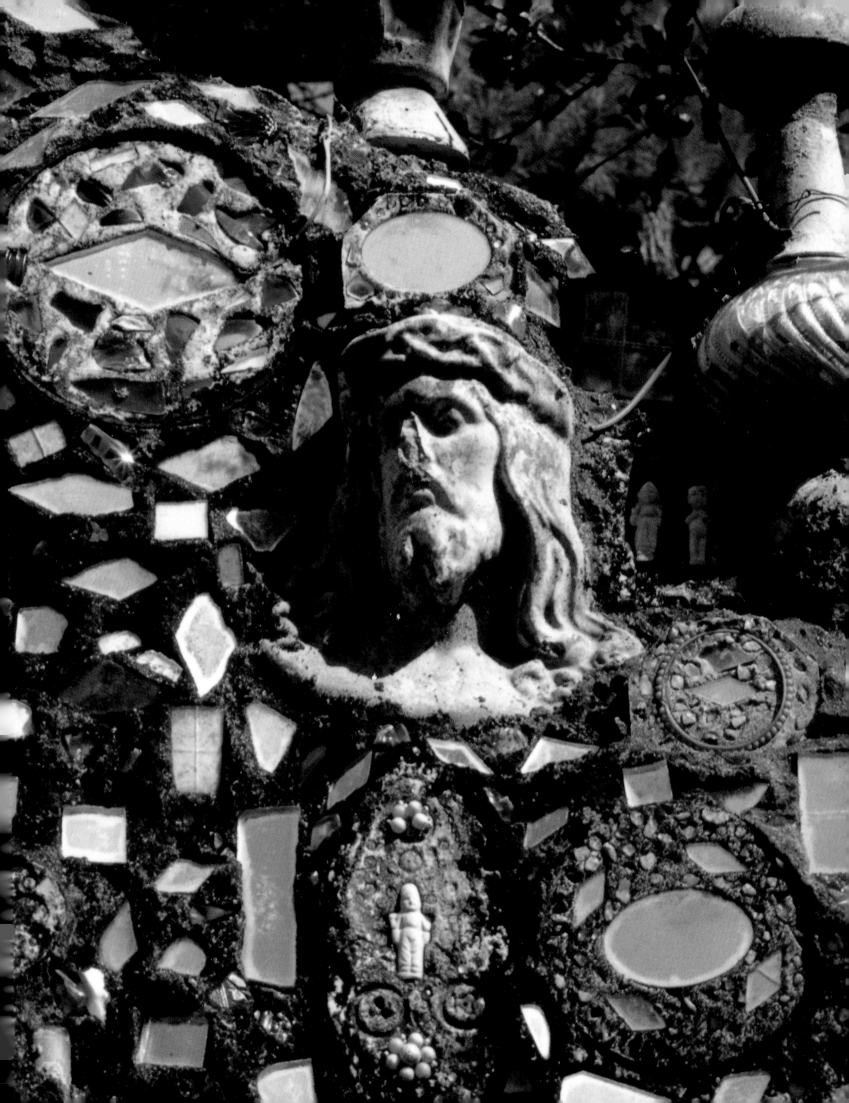

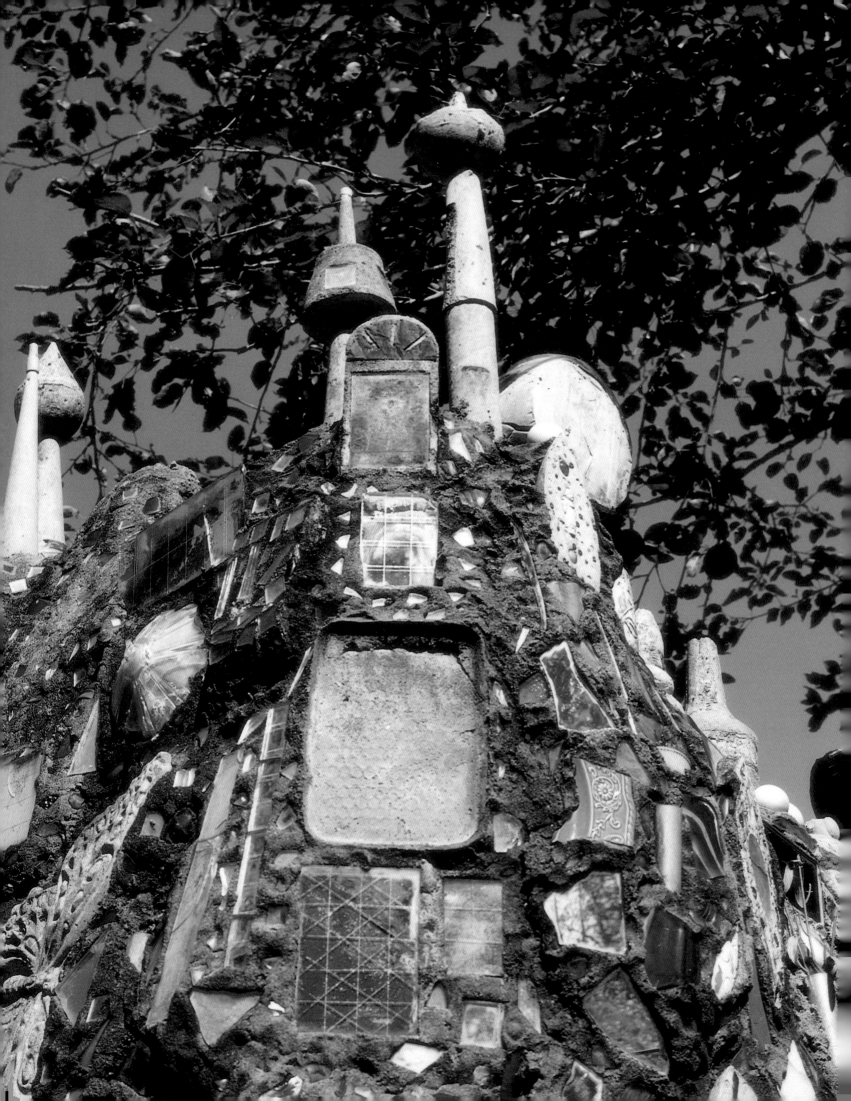

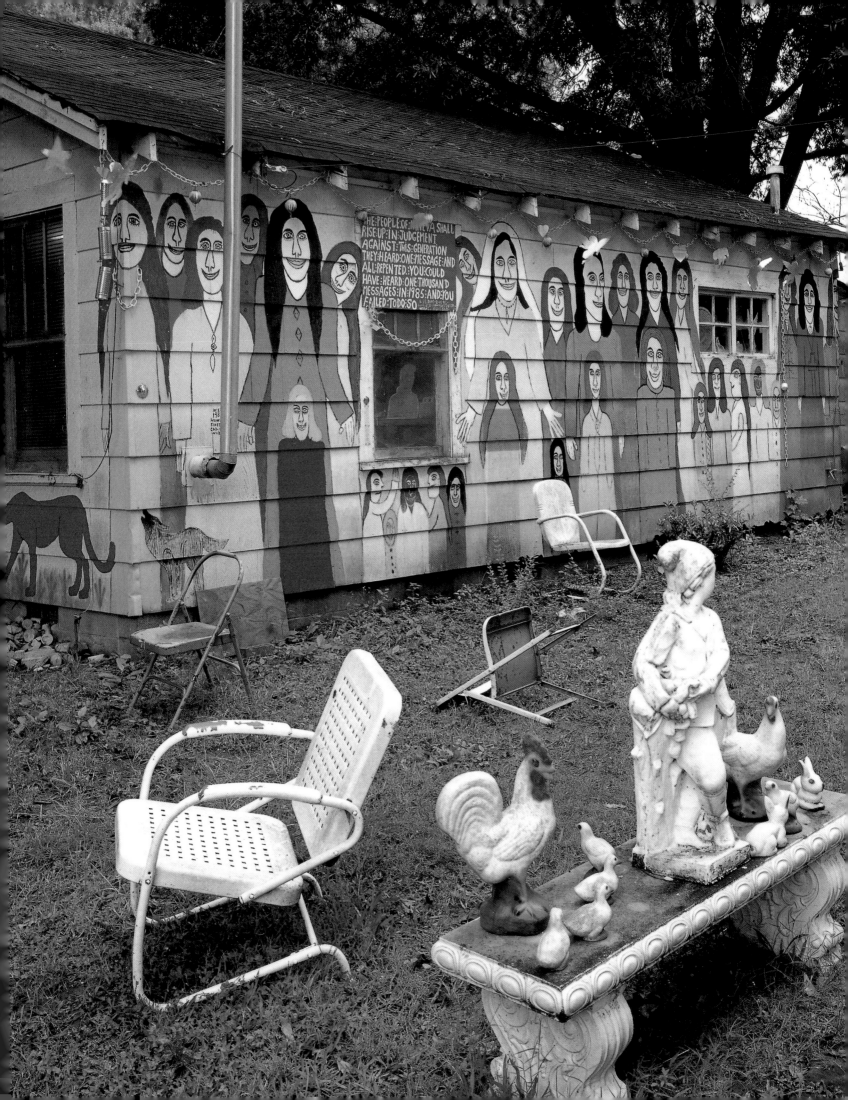

I had a feeling that the world started with a paradise garden. They claim the first Garden of Eden was over there in the Mideast. I thought if the world started with a beautiful garden, then I would like to see it end with one. So I started working on the garden way back yonder, when I did not have anything. I'd watch to see when somebody was tearing down an old barn, and I'd try to get old lumber, and I'd save it, make something out of it.

For me, his paintings, and other kinds of things that I like, serve more as inspirational objects. I got them because they would pick me up when I was feeling low, inspire me when I walked by them. They serve as kind of tools; they inspired me to do my own work.

David Byrne, musician

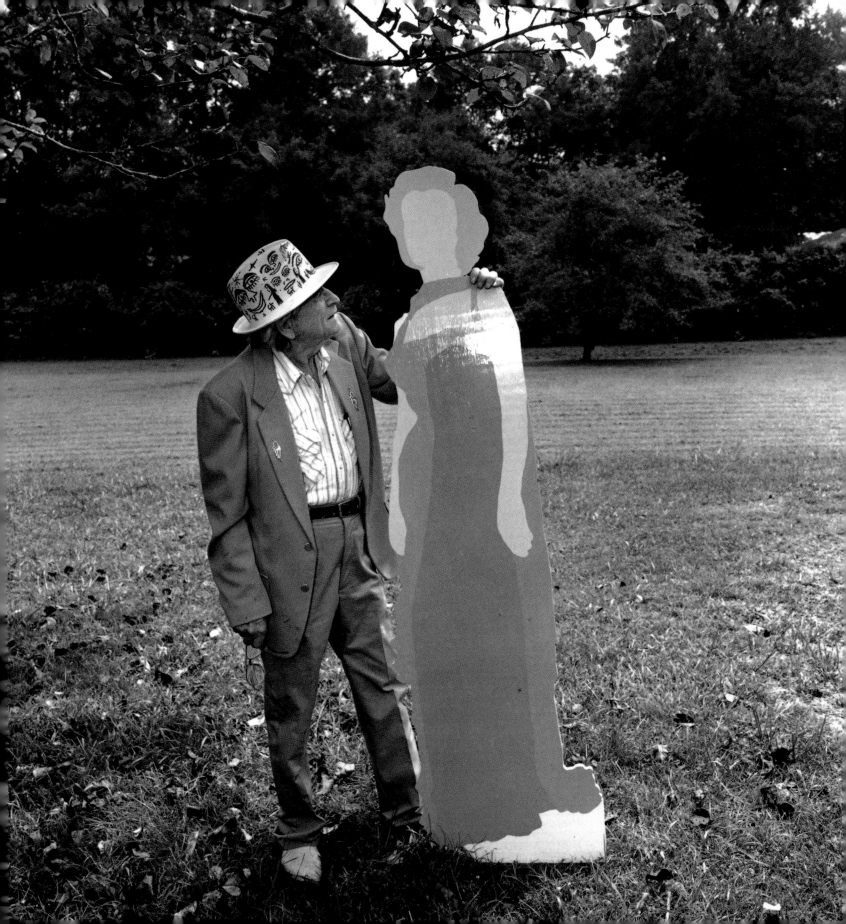

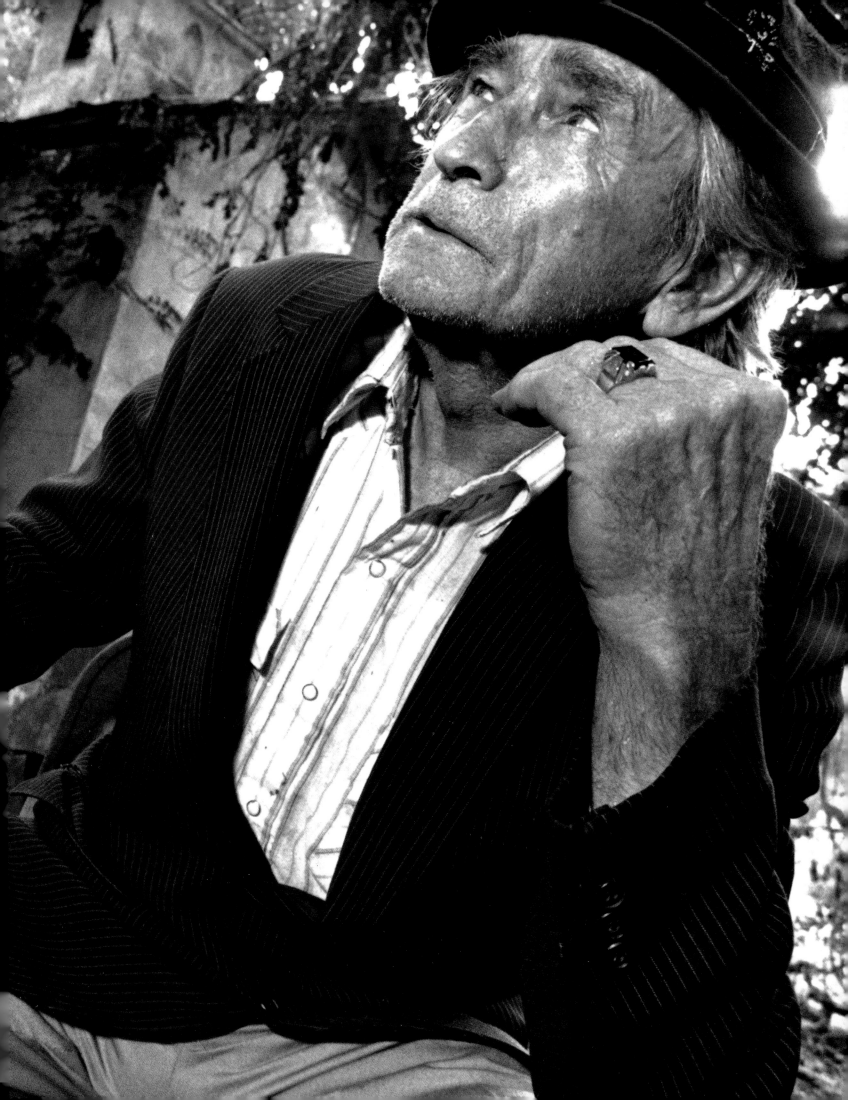

I have a city block here in Summerville which people call Paradise Garden. People eat the grapes right out of the garden. When you come to Paradise Garden, there is a sort of reception area where you can go four different ways. There is main street, going east and west, and another direction going north and south. You come to my studio and say hello, and then you go on to the garden, while I wait and listen for the phone. People call in from across the nation on the phone, constantly wanting art, cards, posters—anything I do. "Howard, why is your art so much wanted now by young people and everybody?" they ask. And my answer is, "I'm in the plan of God, and whatever my art does is from God Almighty, from the world beyond."

My life here on Earth is to give to the people. I was sent here for the people, not for myself. If I had been sent here for myself, I'd been hunting

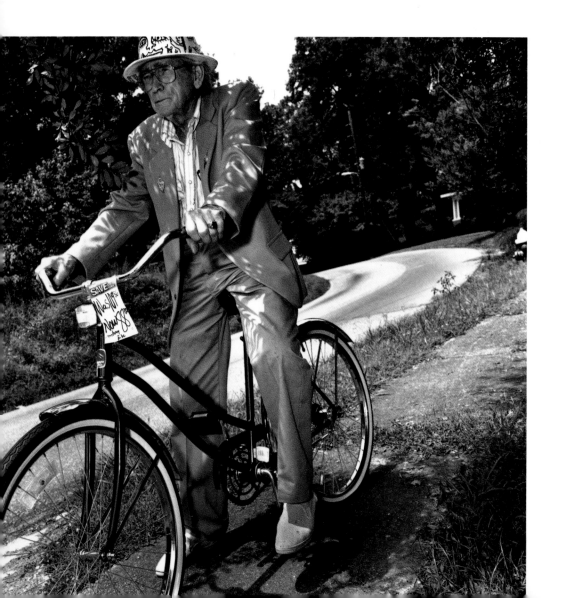

and fishing like a lot of you all. I'd sit in the stadium and watch my grandkids play football. I'd go to the movies and just enjoy this life, if I were here just for Howard Finster. But in case you don't understand, I'm here for you. I can't explain anything much else to you 'cause I've come through the world as a sixth-grade student. Pastored nine churches in about forty-five years, worked with young people, teenagers, children, adults, and now I am reaching more people with my art than I did when I was a pastoring.

In my first garden at Trion—which I had for about four or five years, right in my fenced-in backyard—I built a little shed two stories high. I decorated it up and made special awnings. I made lattice around it, and it was beautiful. It was big enough to go in and sit down. Kids took it for a playhouse, but it was a little mansion. My kids had fun in that house.

Then I made a cement cross and built a four-foot-high replica of the First Baptist Church in Trion, which was just about a mile from where I lived. I got a hold of a lot of old brick and started laying them, making a walk down to the little shed, where you could look through the windows and see stuff on display. That's the way I started out. I was preaching and working in the mill and building the garden. I'd get up Sunday morning, about five o'clock, eat breakfast, go to pastor the church, and then I'd haul gravel to build in the garden.

The next thing I wanted to do was to build the kids a little swimming pool. We dug a pond about two or three feet deep and laid bricks in the bottom. Then we put up brick walls and pumped water out of the well to fill that thing full of beautiful clear water. I've got pictures somewhere of a duck swimming around in it. The kids could go in there and swim, too. Then I began to make other replicas and things—a beautiful little fourteen-foot castle that I painted white and trimmed all the windows with facing. It was one of the prettier gardens I ever laid my eyes on, but it was just too small—only 80 foot on the front and 110 foot on the back. The highway was going to be built through there, and we was betting on whether they'd run the highway to the back of us instead of the front, but we lost out. But by that time so many people were coming through the garden I didn't have room.

Songs

I make up my own songs, and I sing them myself. I like other people's songs, but I'm not really what you call a singer. I sing my way, and I sing what I want to sing. I get a subject on my mind, you know, like clouds, c-l-o-u-d-s. "Well I was in space far, far away. I come down to the light of day, down through the clouds, so snowy and white. I couldn't help but think I am just right. I went with the wind and floated with the cloud, and the wind was blowing, blowing so loud." They are really songs for me, but there are lots of other people that likes them. So I make tapes here and sell them for five dollars a piece. Just cheap tapes. It helps me fix my garden up.

Howard Finster

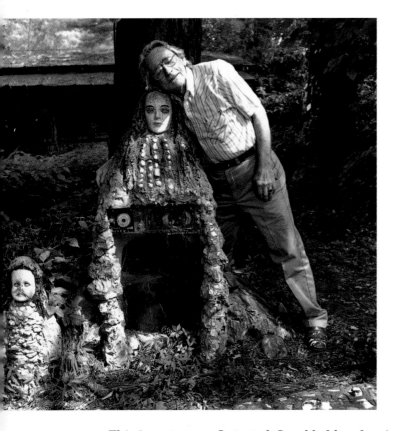

The Stranger and Child

This is a stranger I started; I molded her face in a shoe box. I put her on top of a TV set. My plan was to have a tape player you could turn on, and she could talk to you. I never did get that part of it done. Her hair is supposed to go plumb down to the ground on each side. This little baby here, I put a couple of bricks under his hands to hold them up; they look like little suitcases, so I just left them there.

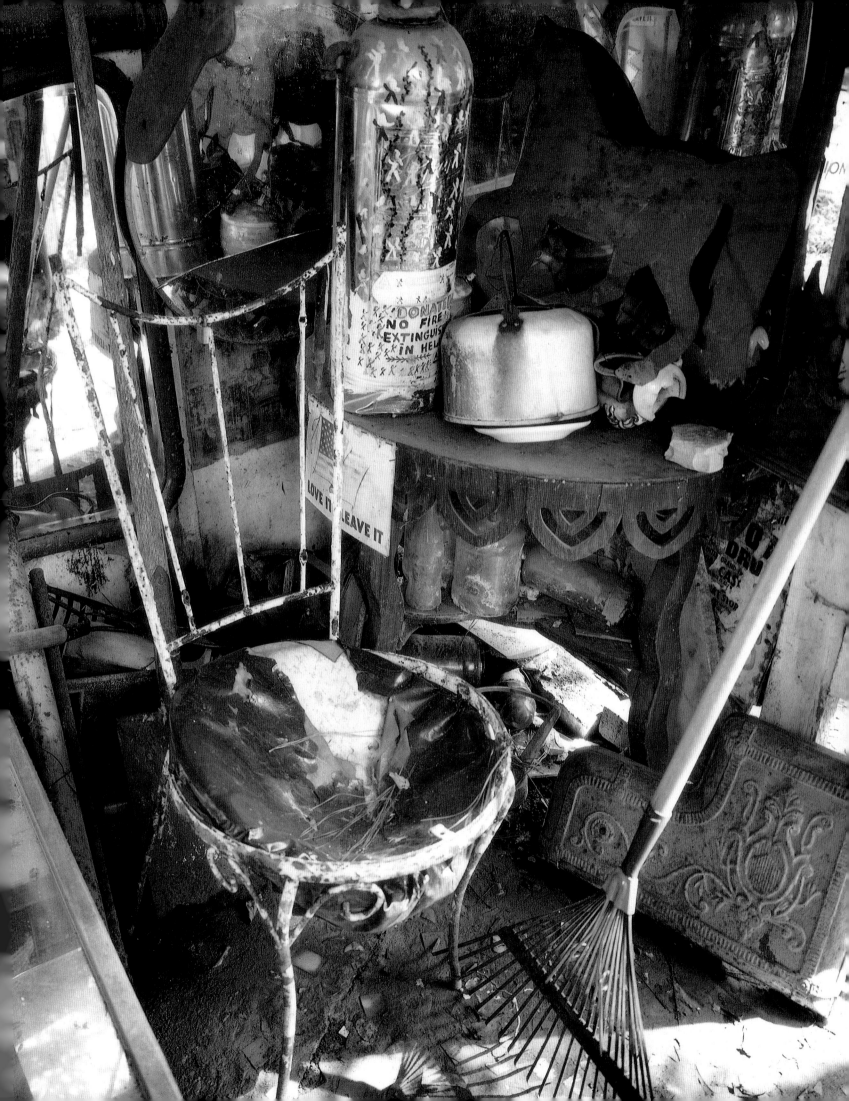

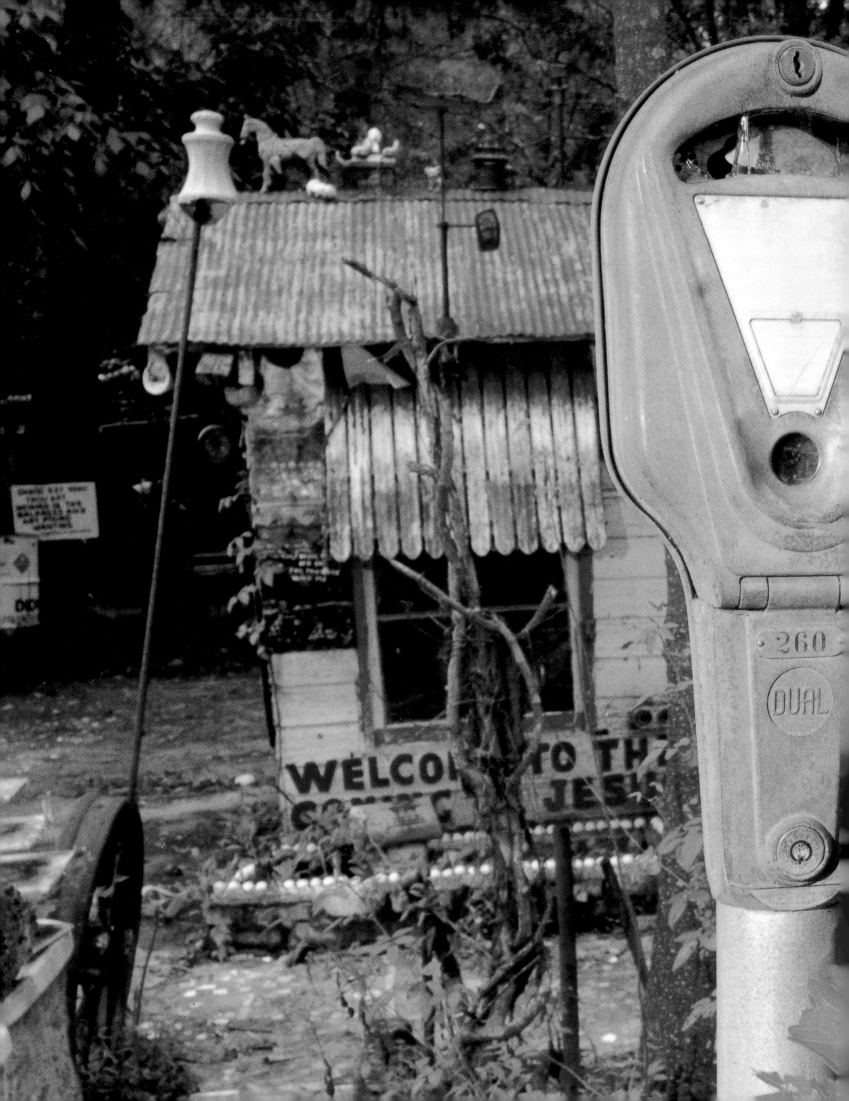

The bottom line is that an artist is someone who just can't help but to make art, but it's not something he or she decided to do, like going to dental school to become a dentist; it is something much more obsessive, or compelling or compulsive, if you will. It has its own built-in need as it were. I think that the people who go to school to become artists are exercising, as if they were doing calisthenics to get ready to do ballet. So in fact, if you analyze it, all that we see when we look at art has several components, actually two major components. One is the kind of feeling this person has, or message, something they have to say, and the other is some kind of controlling, intellectual phenomenon. The third little piece is this muse, which nobody understands at all, least of all the artist. Everybody's art has these two things, the emotional side and the controlling side, and this other little piece that connects them. It is also frequently true that an artist makes wonderful things, and the last thing in the world they think of as important, that is, the thing they take for granted about their work, is the most important thing about the work to the viewer from the outside. But every once in a while, somebody does something for a purpose that has nothing to do with art and the by-product of this is a work of art.

Phyllis Kind, art dealer, New York

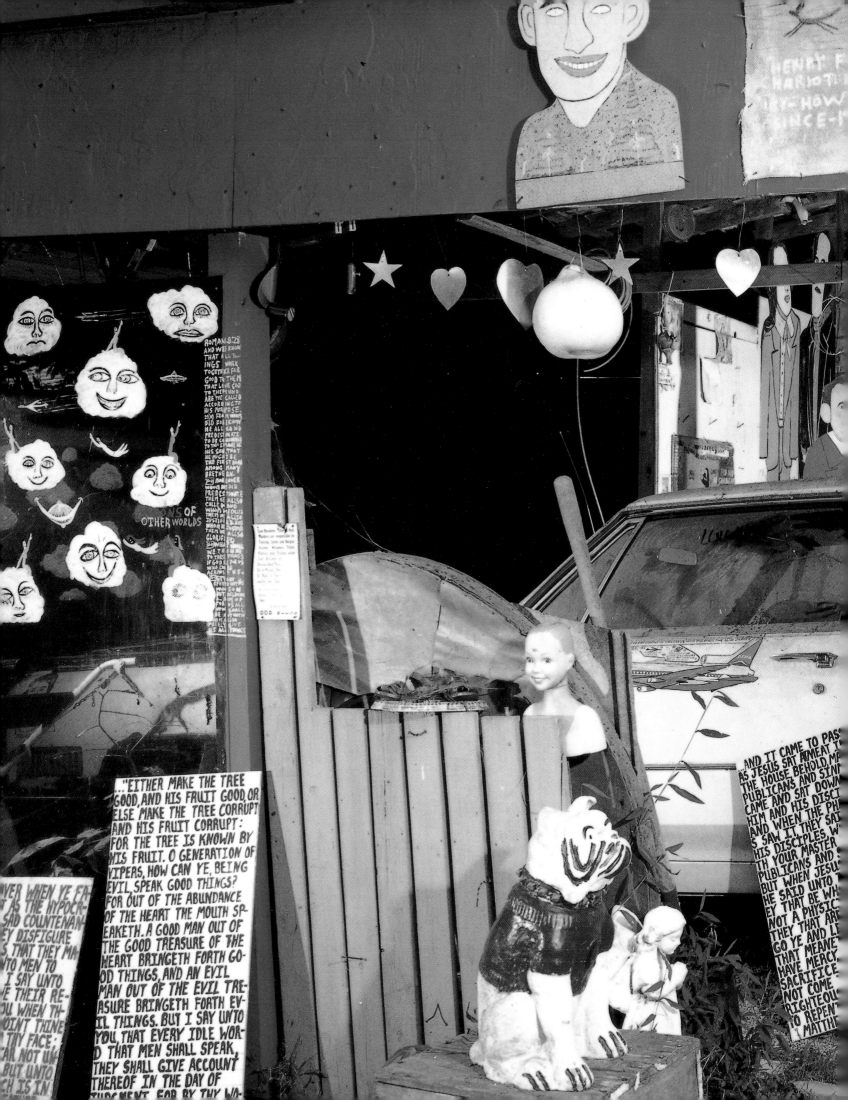

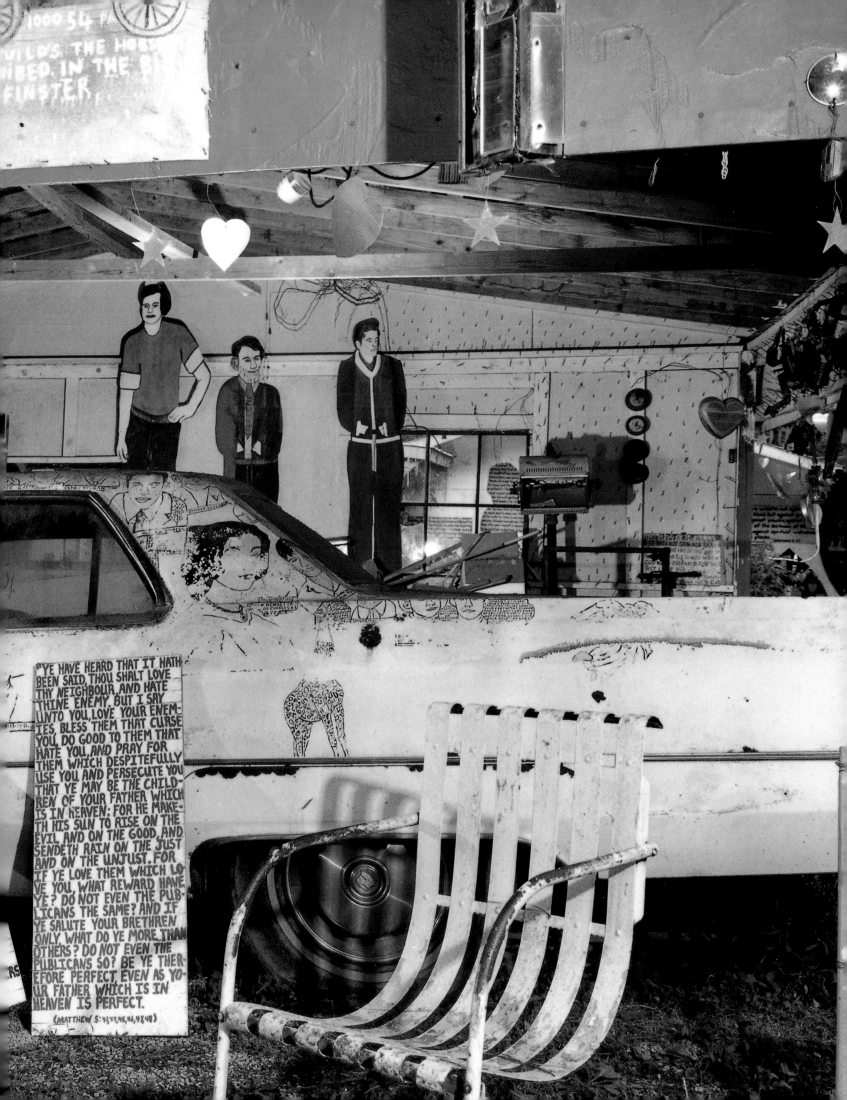

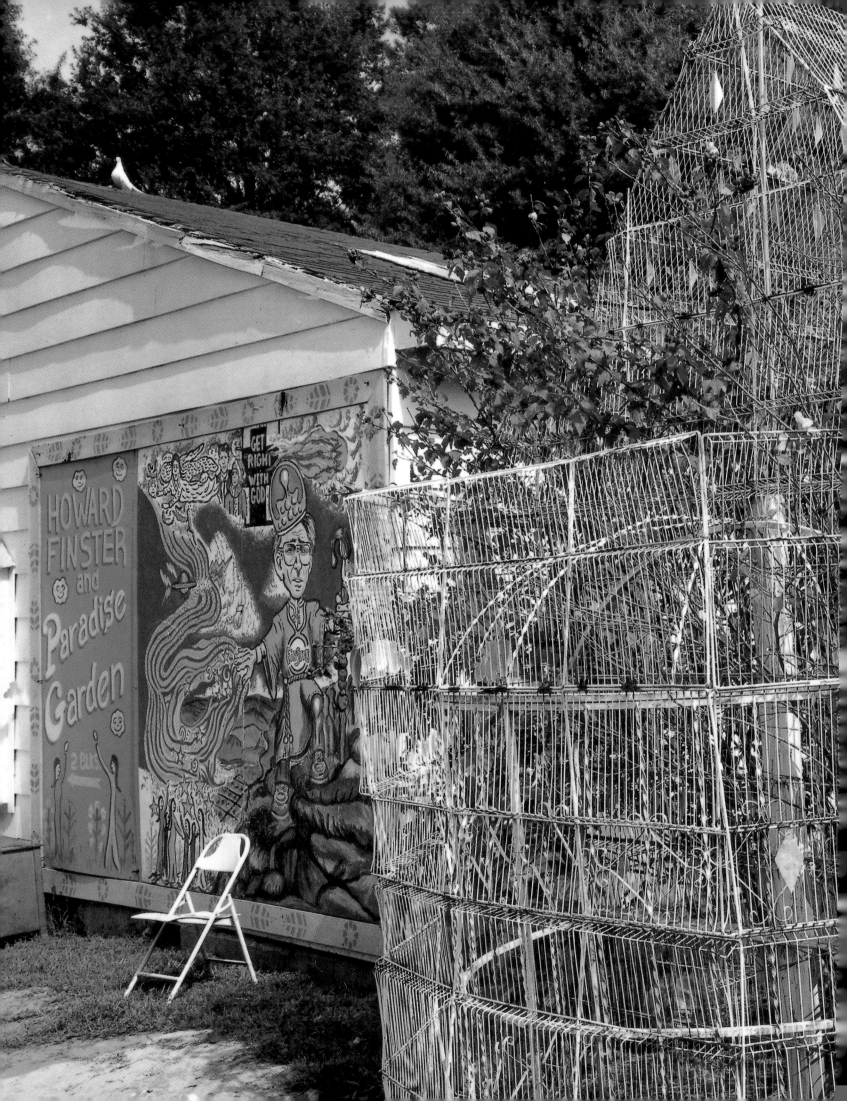

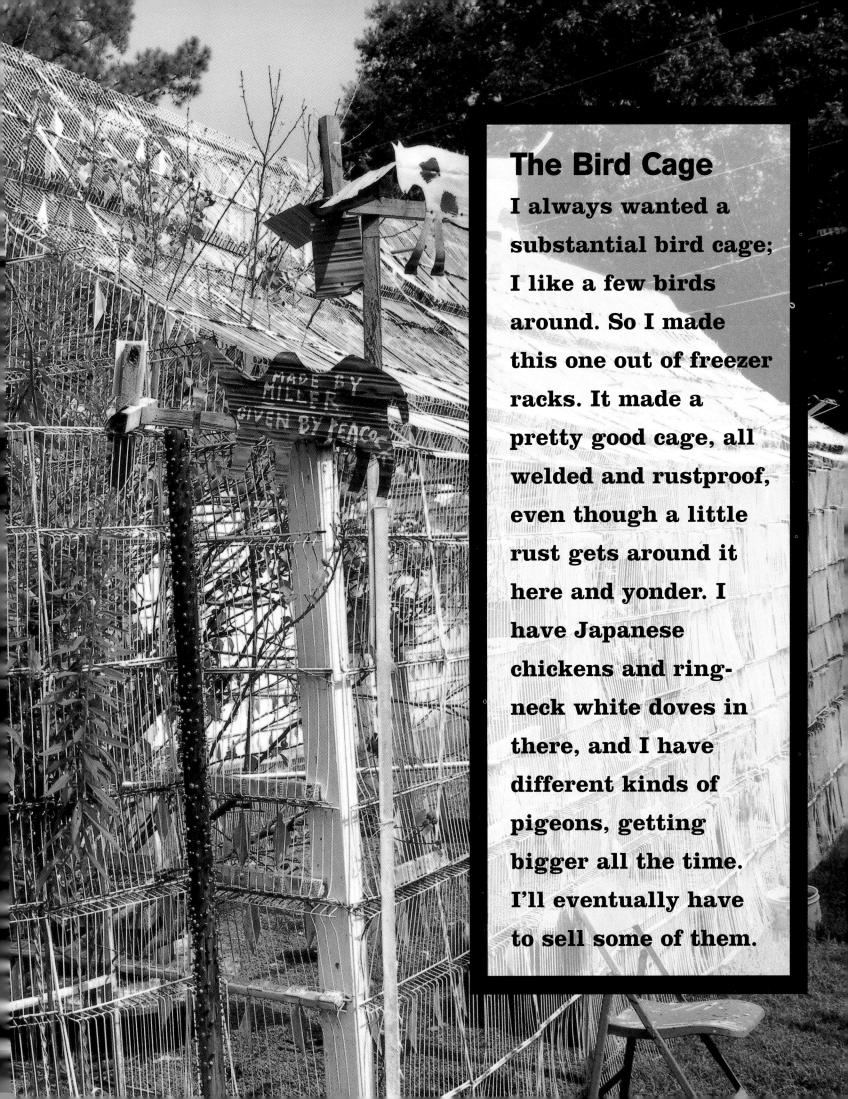

The Bird Cage

I always wanted a substantial bird cage; I like a few birds around. So I made this one out of freezer racks. It made a pretty good cage, all welded and rustproof, even though a little rust gets around it here and yonder. I have Japanese chickens and ring-neck white doves in there, and I have different kinds of pigeons, getting bigger all the time. I'll eventually have to sell some of them.

We sold the Trion house for $2,500 and come down here and started this second garden. I bought this lot in Penneville for $1,000; the woman begged me to buy it. You had to have boots to cross the land or you would mire up in it. It was just old water and mud. Mosquitoes and gnats everywhere. People had throwed old Christmas trees and lard cans, everything. You couldn't get in there with no kind of instrument to do nothing; a caterpillar would just go plumb up. I got a load of slabs and stuff, and I'd stand on those slabs and rake the mud on both sides to free up the streams so they could flow. I got a vision to open up a stream all way across that garden, plumb down to the other end of it, where the pump house is now. It's where the original entrance to the garden used to be.

So I could construct the first walk in the garden, I opened up a ditch two hundred, three hundred foot, and the water would run in that ditch right down through to where a kind a lake was. The water flowed, and then when the rains came, they would wash it out a little more. That really gave me a blessing.

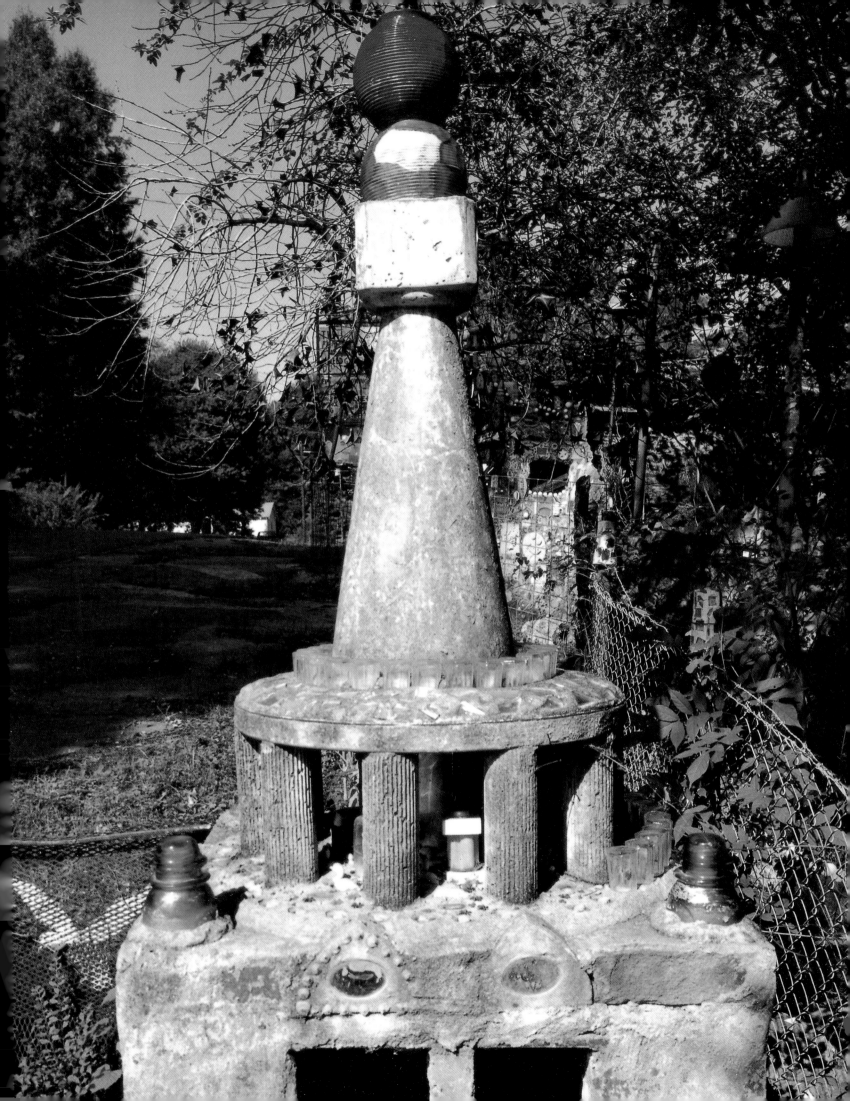

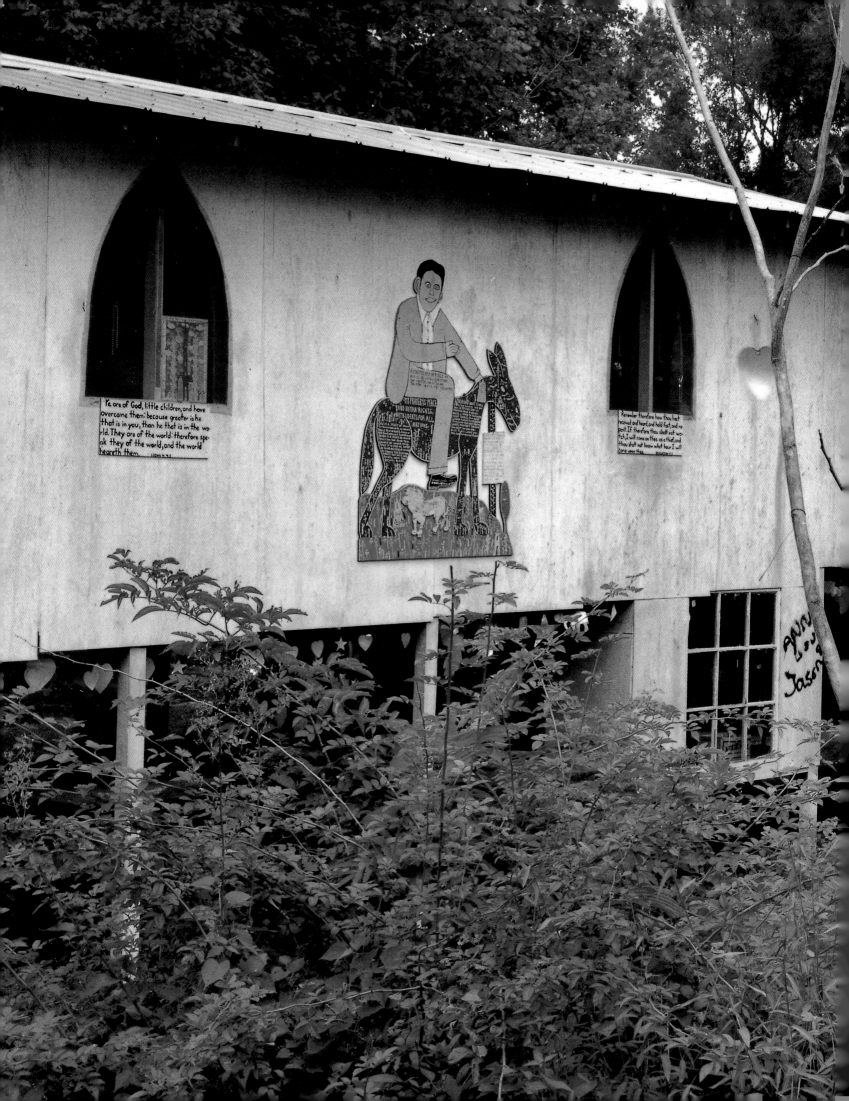

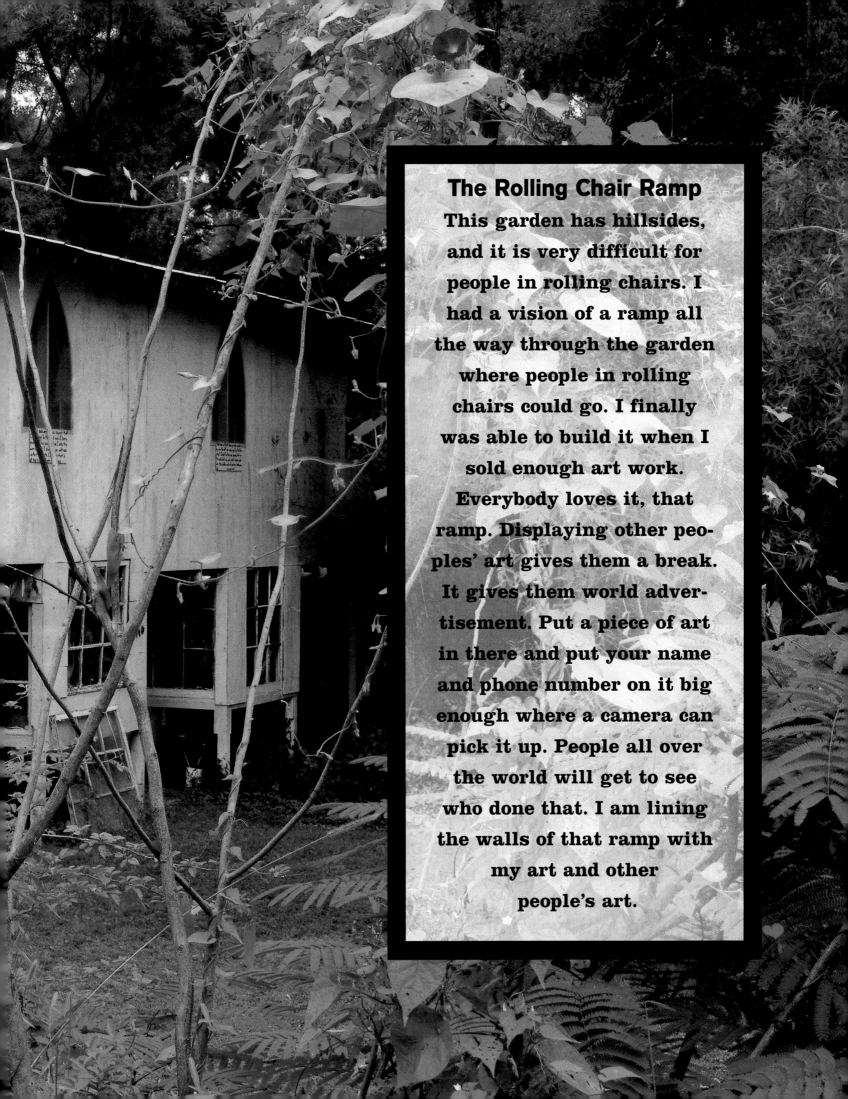

The Rolling Chair Ramp

This garden has hillsides, and it is very difficult for people in rolling chairs. I had a vision of a ramp all the way through the garden where people in rolling chairs could go. I finally was able to build it when I sold enough art work. Everybody loves it, that ramp. Displaying other peoples' art gives them a break. It gives them world advertisement. Put a piece of art in there and put your name and phone number on it big enough where a camera can pick it up. People all over the world will get to see who done that. I am lining the walls of that ramp with my art and other people's art.

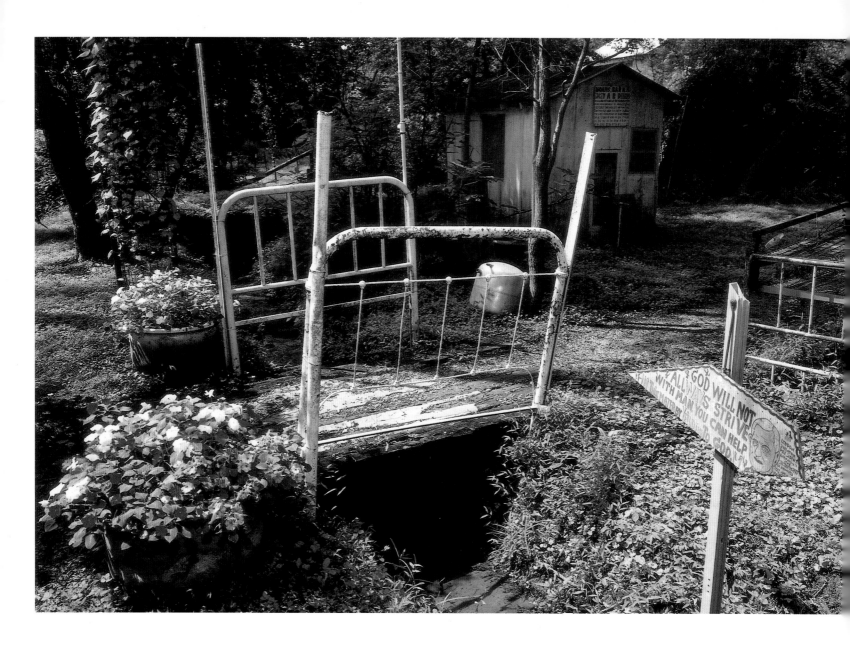

After I got that ditch opened up, I could walk around over the ground, you know, and throw old red dirt on top of the other stuff. By 1962, I finally got it filled in where I could make the first walk, and I put my first little exhibit, about twenty-five to thirty foot from my house. After I got that done, I thought that was as far as I would ever get 'cause I had used the land all up. Well, this woman sold me two more lots over in the Worlet Woods, and eventually, in 1990, I bought two more lots from her, that put me over to where the big pine tree is.

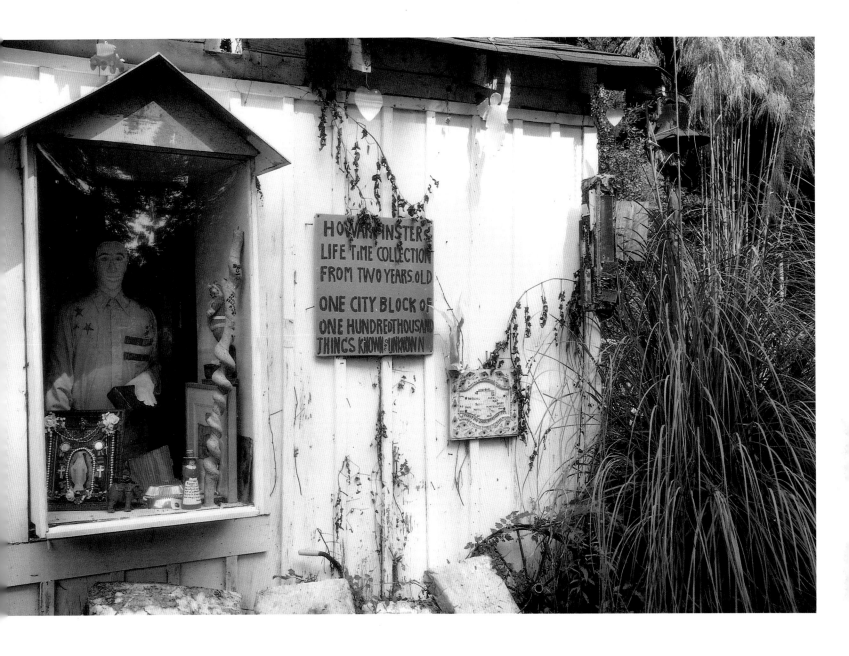

It seems like everyone in Athens, GA, knows about Howard Finster, and a lot of people have Howard's work hanging up in their houses. At the time I first saw Paradise Garden, Howard wasn't a folk art superstar; well, I guess he really was a folk art superstar then, but he seemed like just an interesting person to visit. He's such a wonderful man who emanates a lot of good, sort of powerful, feelings. He has this tremendous energy, and going to the garden is always like a secret journey. The first time I went to see him, he was working nonstop because he had a show coming up and he didn't even have any pieces available to sell except one piece, which I've had hanging on my wall ever since above my bed. It's one of the angels with the horn. It's so wonderful. It makes me feel great whenever I look at it. It's just very uplifting.

Kate Pierson, musician

I'd go to the dump and collect all kinds of beautiful things. At the time they had open dumps, where everybody dumped. When people's loved ones died, they would clean up a house. I would go there and get the stuff they throwed away—old trunks, boxes with jewelry in it, all kind of stuff. I'd collect beautiful glass that would get broke or burnt in a house fire, beautiful pieces with twenty-two karat gold on it, keepsakes, things that would have brought a lot of money. I got out there one day, and I poured about a three-foot walk, in a square, and I had a vision to decorate it with my collections, beautiful glass and all kinds of things that would not rot or rust. Tiles, broken glass, stuff like that. Stuff that might last you forever.

The first section I made was out of this world. It was a beautiful thing; it looked like the creation of God and man. So I built another three-foot square, and the first thing you know I had that thing twenty-five foot long, and it was so beautiful I just kept going with it. I went on about a hundred foot with that walk, just molding and inlaying, down to where the pump house is now.

I decided to build me a pump house and put a pump in the branch, so I could wash my walks off. Coca-Cola bottles were the cheapest thing I could build the pump house with. Back then it was hard to get money to buy blocks and everything, so I started going out and picking up glass Coca-Cola bottles by the loads, sacks full. I even bought a bunch from a guy. I cemented the walls with the Coca-Cola bottles in sideways and put marbles in them, and you could see the marbles from the outside. I had a bunch of these little magnesia blue glass bottles you never see anymore, and I started decorating with that beautiful blue glass around the bottles. I got the pump house up pretty well, except for I never did get the sides finished like I wanted them.

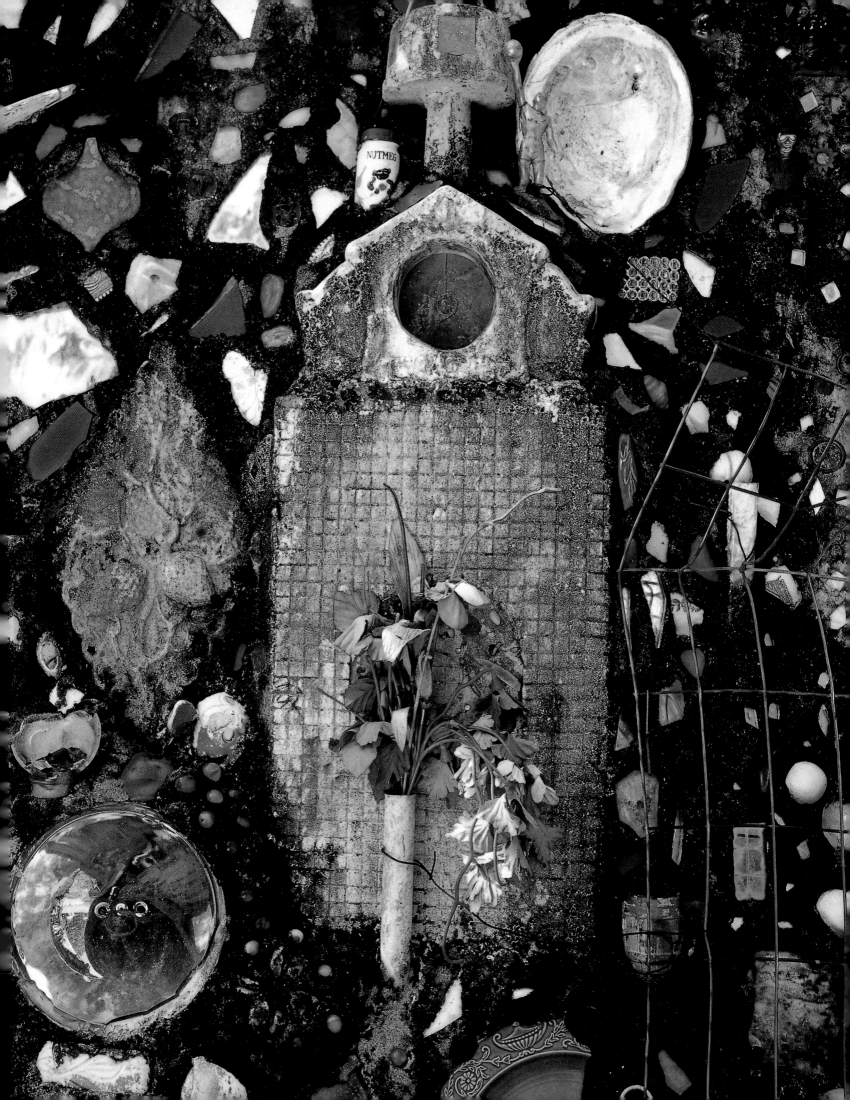

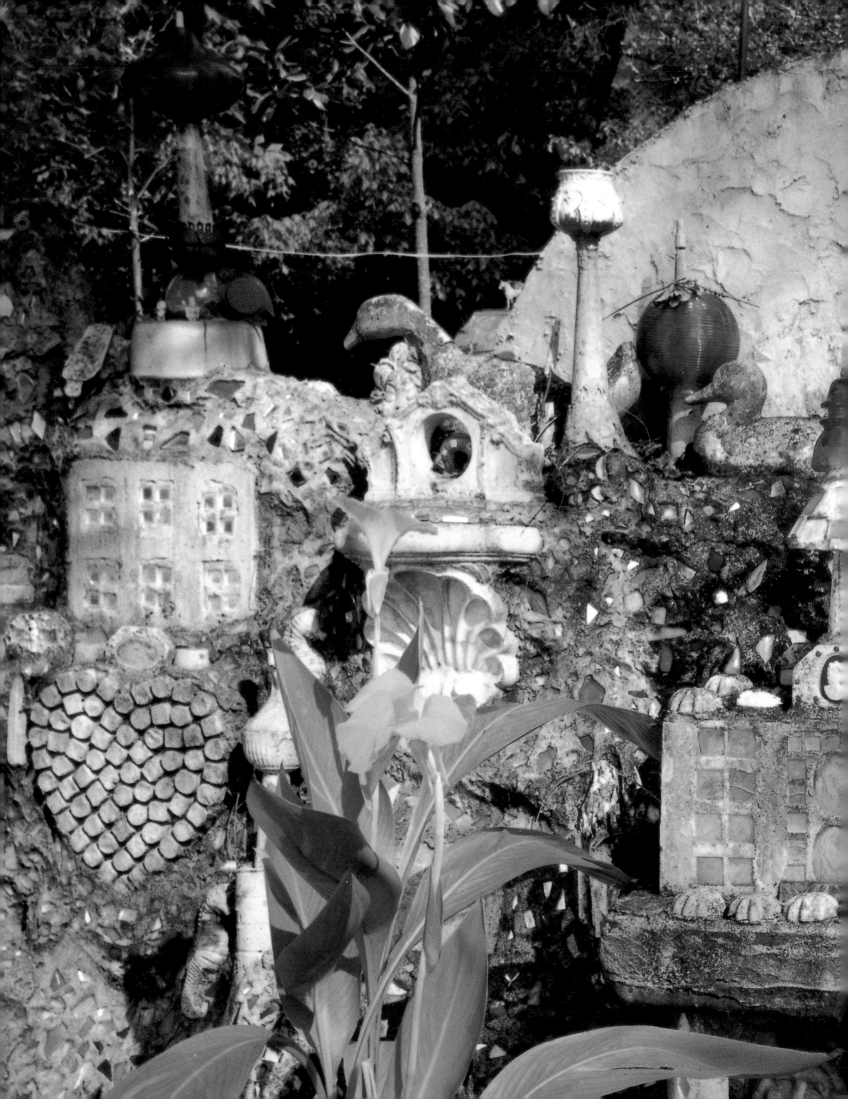

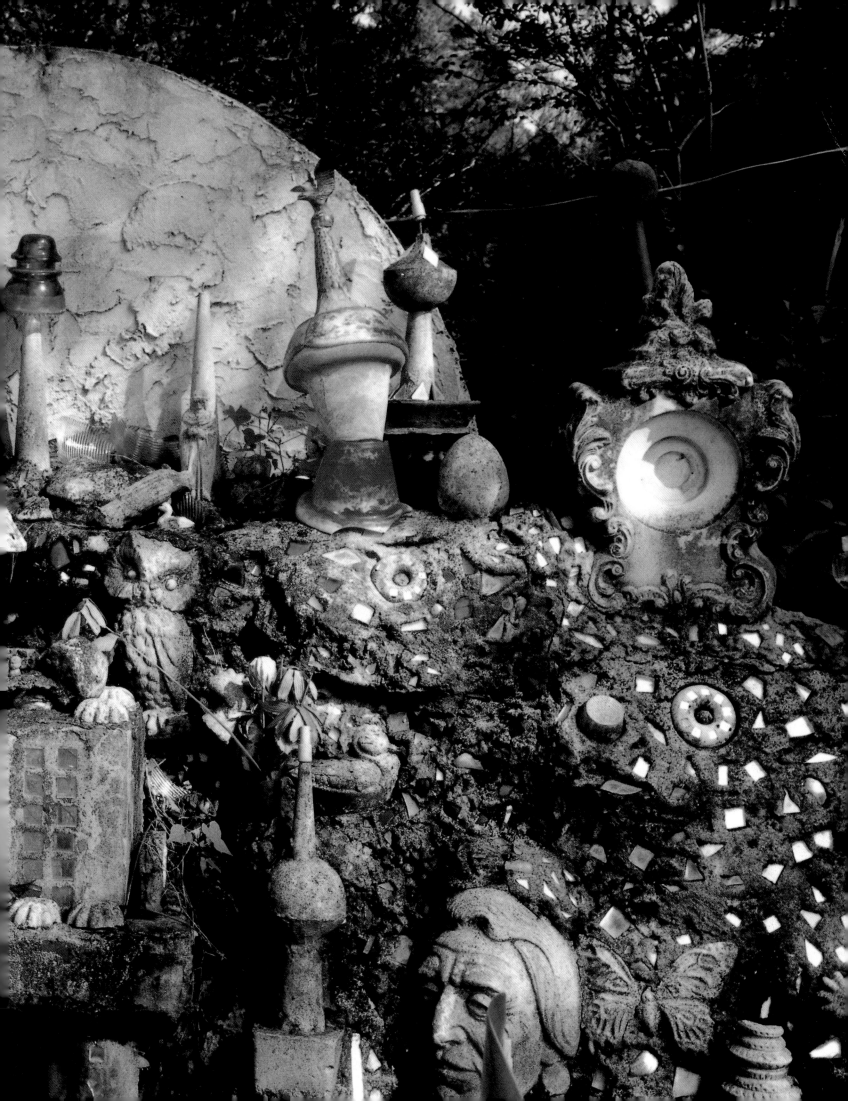

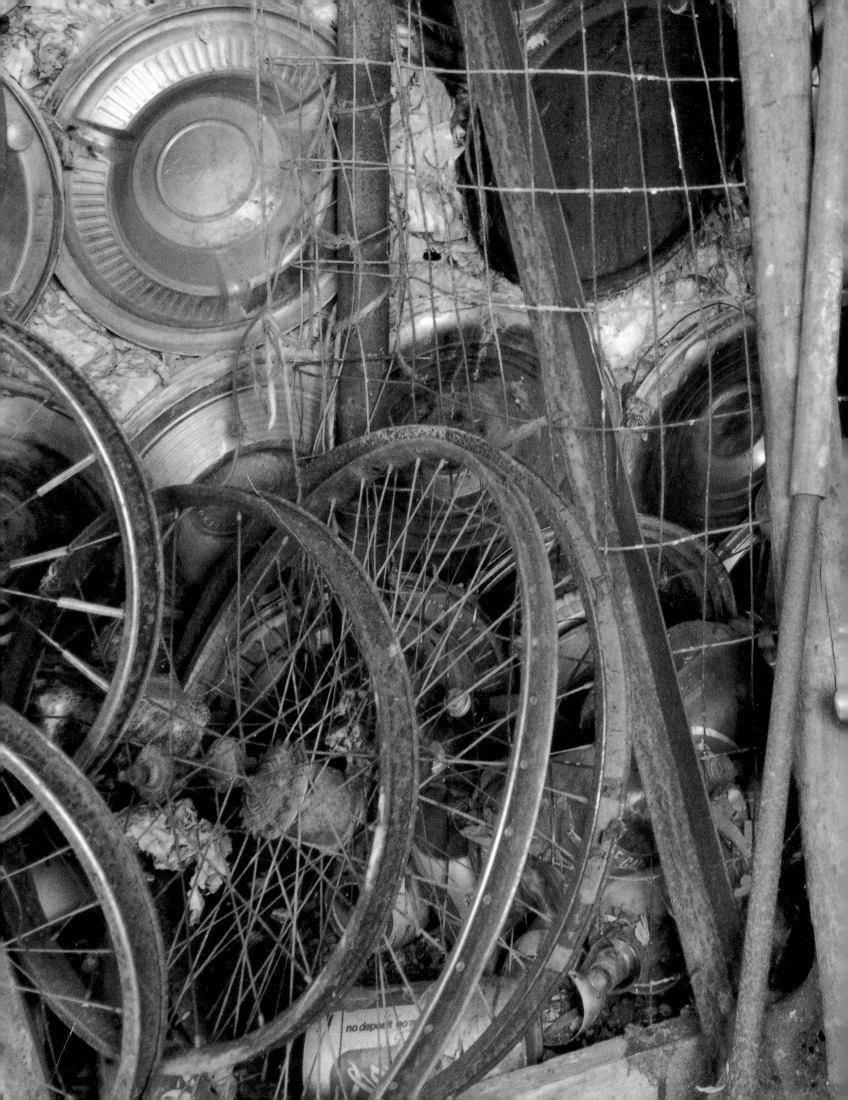

The Bicycle Tower

For several years I pastored churches, and when Christmas time come, a poor kid might not have a bicycle. The other kids had new bicycles, but they wouldn't let them poor ones ride. It was pitiful to see a kid out there wanting a bicycle, so I got to reworking old bicycles year round, and I painted them with stripes. You know that was probably the first time I painted; some of them looked better than ones bought new. The frame is something you don't ever need new on a bicycle; it don't ever wear out. I'd take the parts off one to fix another. So I had a lot of bicycles around here, and a lot of frames. Well, I never thought I would need the land where I was putting them, so they just kept growing and growing. Then I just had to do something with them, so I made big towers out of them. We raise food off them towers. One has grapes growing in it. Another beans. And little animals, they hibernate in there—possums, little ground squirrels go in, and so do dogs. Nothing can bother them.

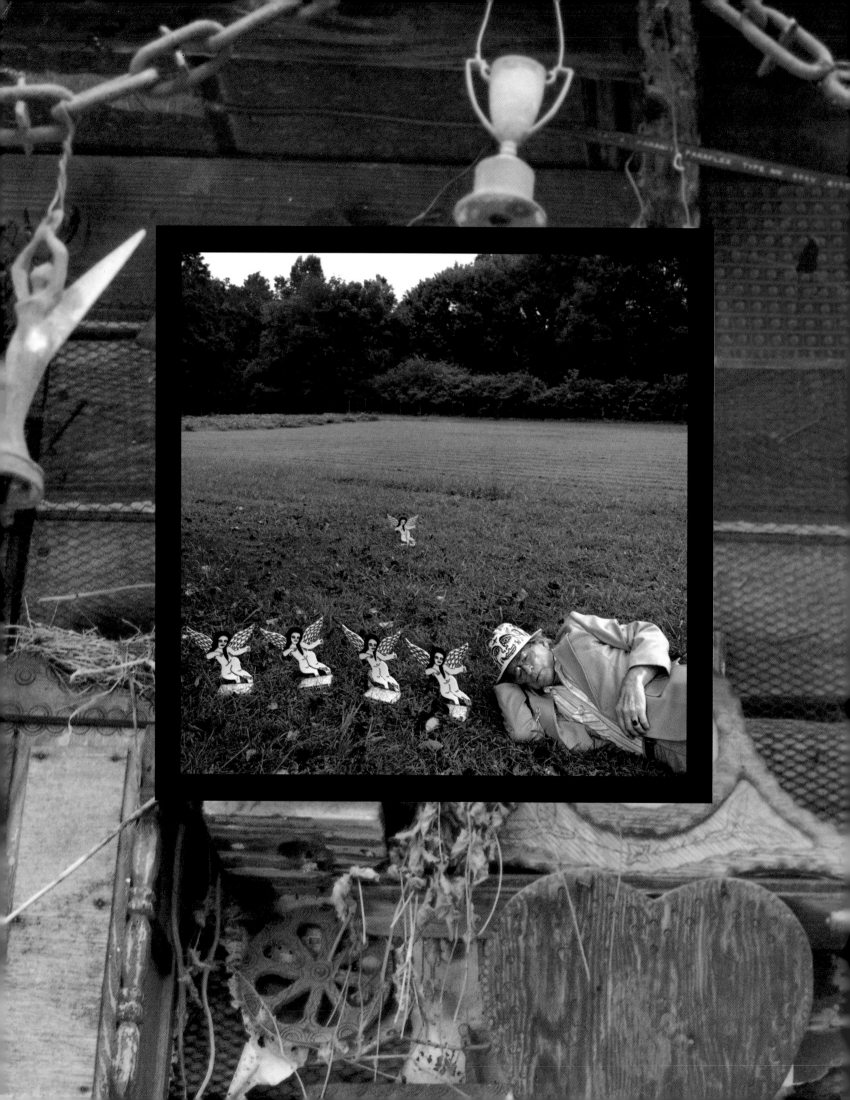

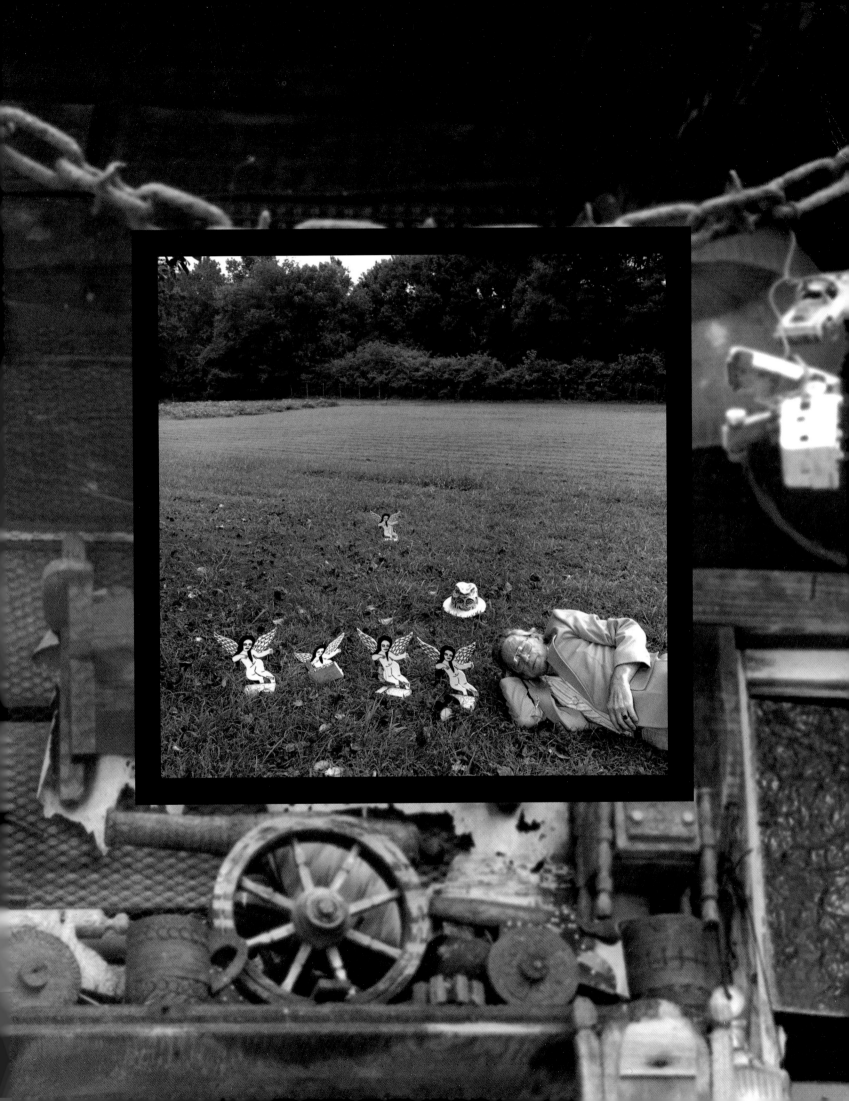

After I built the pump house, I built a sculpture as tall as I could with little mirrors all through; it looked like it was full of holes. Then I made another monument on up towards the house, "The Stranger and the Child." I had bought a bunch of old shoes, sacks and boxes full of them. I'd been painting and selling them. I took those shoe boxes and used them to mold a human face. That is what you call real cement ceramic. I had visions of how to do every single thing.

I built that cement mountain, forty to fifty foot back from the road. I took old TV chassis, old car hubcaps, and iron pipes. I've always been a fella who saved these iron pipes, you know. I drove them in the ground, like a wigwam, and made a mountain. When I covered it with cement, I leave little holes in the cement where little animals and things could go in and hibernate, and it left an environment for ground squirrels, spiders, everything. I left one side of that mountain open and left an old TV chassis show to let the world see what it was made out of. On the other side, I decorated it beautiful with all kinds of stuff. You could see through it with them mirrors on it, and I liked that.

I would buy up a bunch of ten-cent bugles, paper party bugles, and use them as molds. I'd turn them upside down and pour cement in them, then stick a wire in. They were like little steeples, and I'd put them on top of my buildings, all over the garden. I also used large paper milkshake cups for molds, and stuck pieces of glass on the inside of the paper cups, so the glass was embedded in the cement. Then I'd stick a bolt at the top and let it stick up about four inches. When it dried I had a big, beautiful, cement, mirrored knob. I'd take a pipe and tamp paper down in it about six inches and pour cement in the top of that pipe and stick it on the knob. They made beautiful fence posts. Some of them got beat up and things like that. Tourists, through the years, broke a lot of them, but there are a few of them still down there.

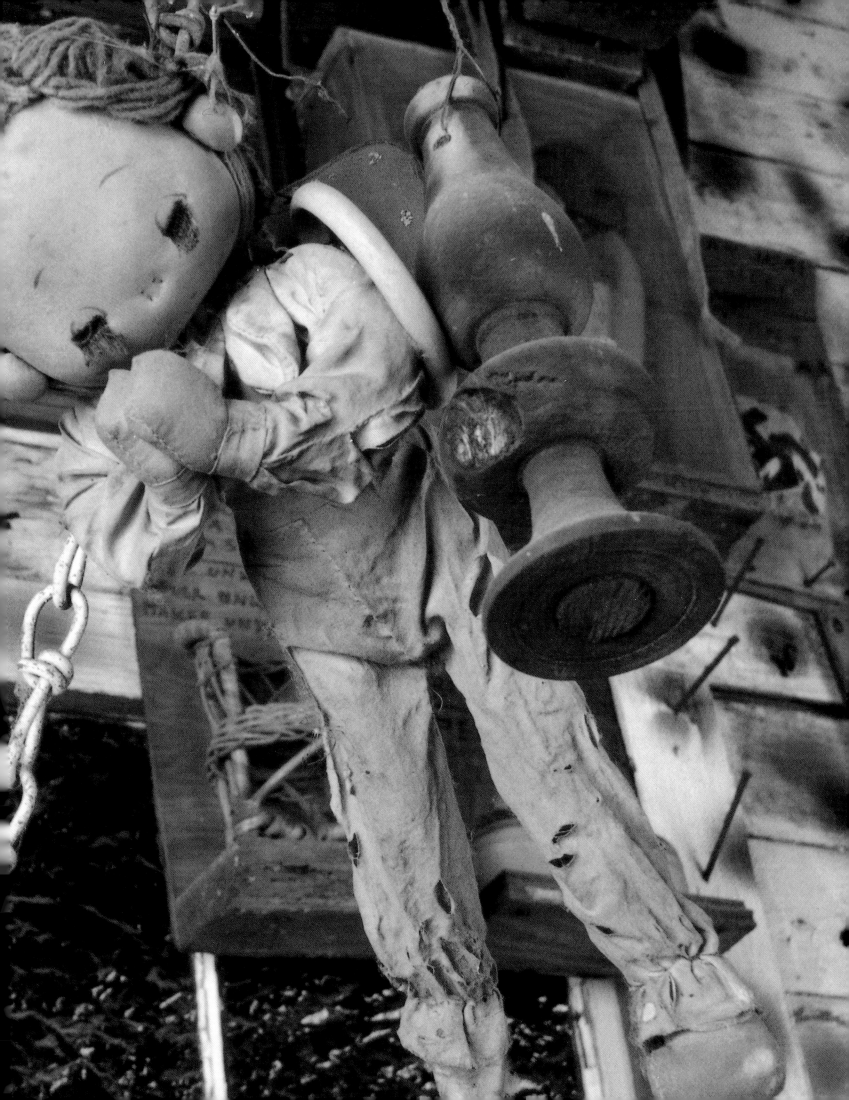

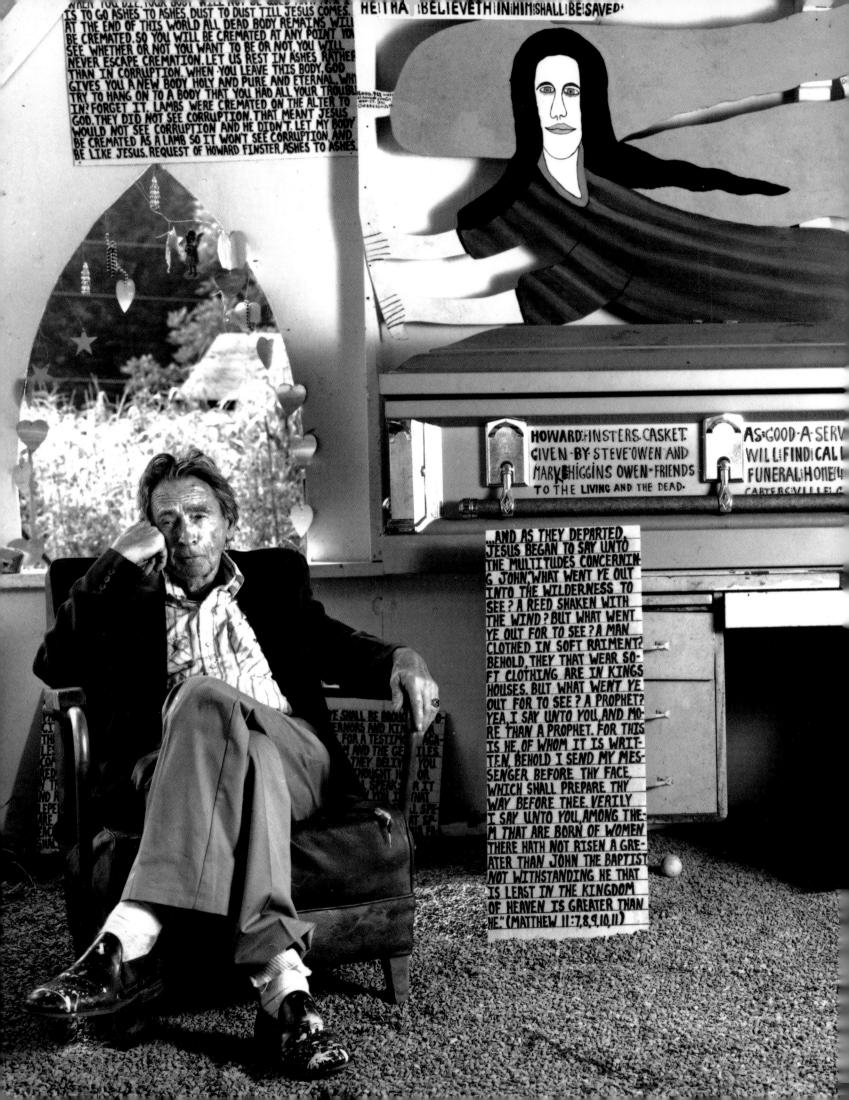

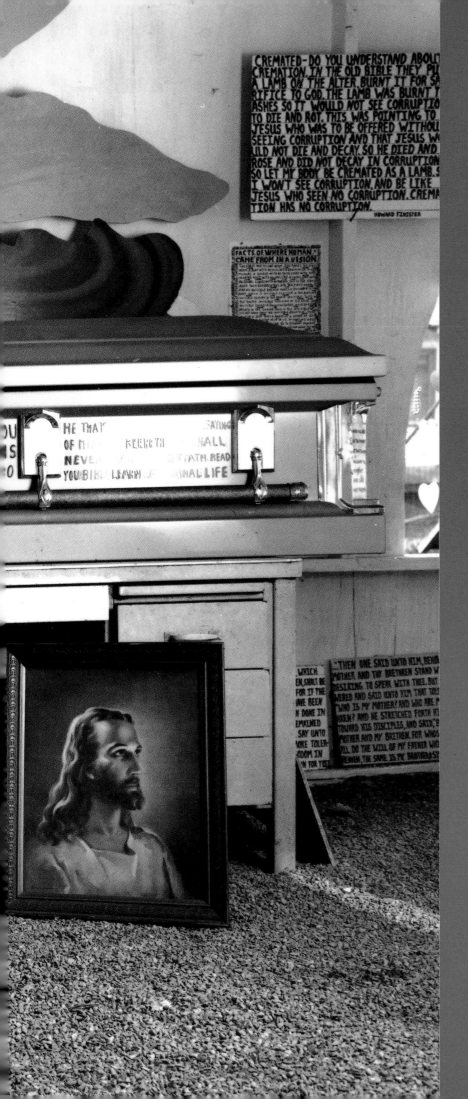

The Casket

I had a funeral home come here and ask what they could do for me. I couldn't think of nothing except that they could give me my casket. When they brought it, I set it on this table. It's a nice one, with a steel vault. Anyone who writes me a two-inch-square letter on one side of the letter and signs their name on the backside of it, that little square will go in my casket. I figure I can put a million in there.

I had a vision to be cremated and my ashes put in my casket. People who are cremated see all the animals that were offered to God for man's sins over thousands of years. You know they had to cremate them animals before they were acceptable, because cremation does away with corruption. Cremation is the only way to escape corruption. Corruption is where you rot and stink. So I want to be cremated, and then Christ won't see no corruption. I would be cleaner. I could be cremated in three hours. It would be a sacrifice to God. Then he could accept me. Embalming anybody is prolonging corruption. When you embalm anybody, you are saying against the Bible, "I don't want to go to dust." You are suppose to go to dust. Your body ain't suppose to be seen anymore because God gives you a new body. When you get that new body, you won't need that old one. What does it make any difference where it goes?

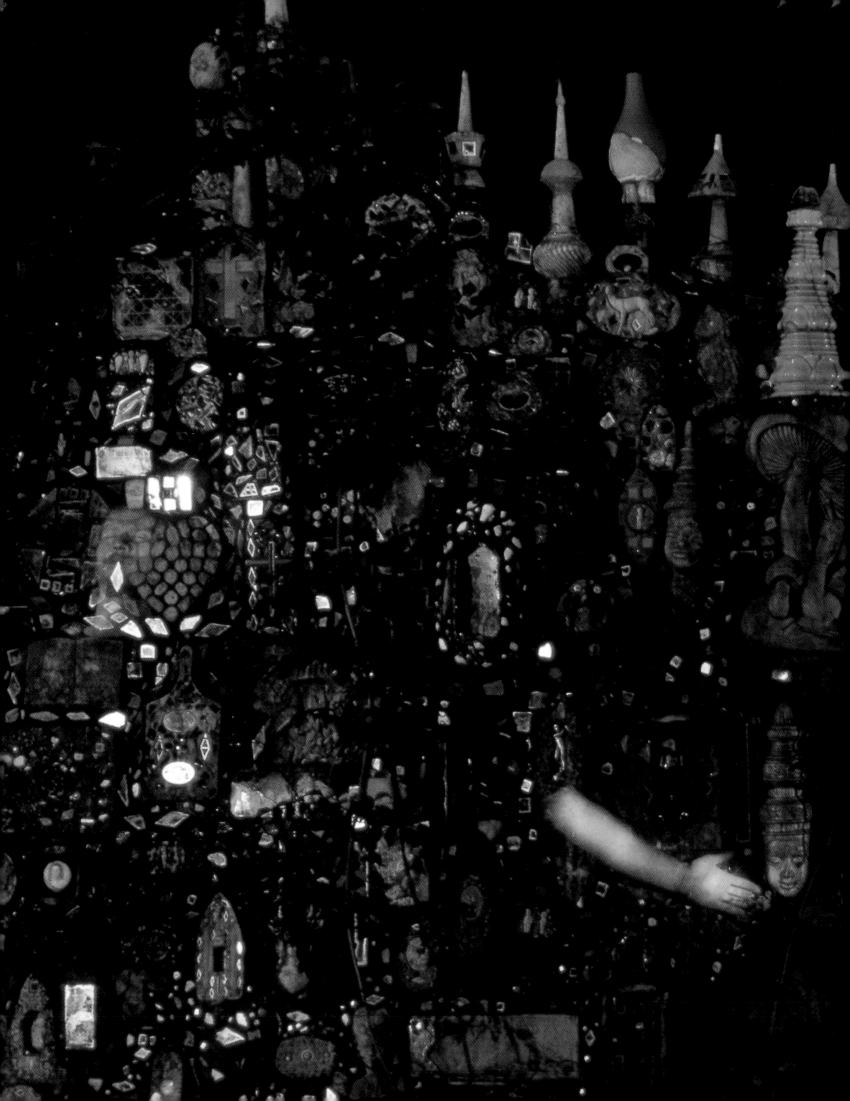

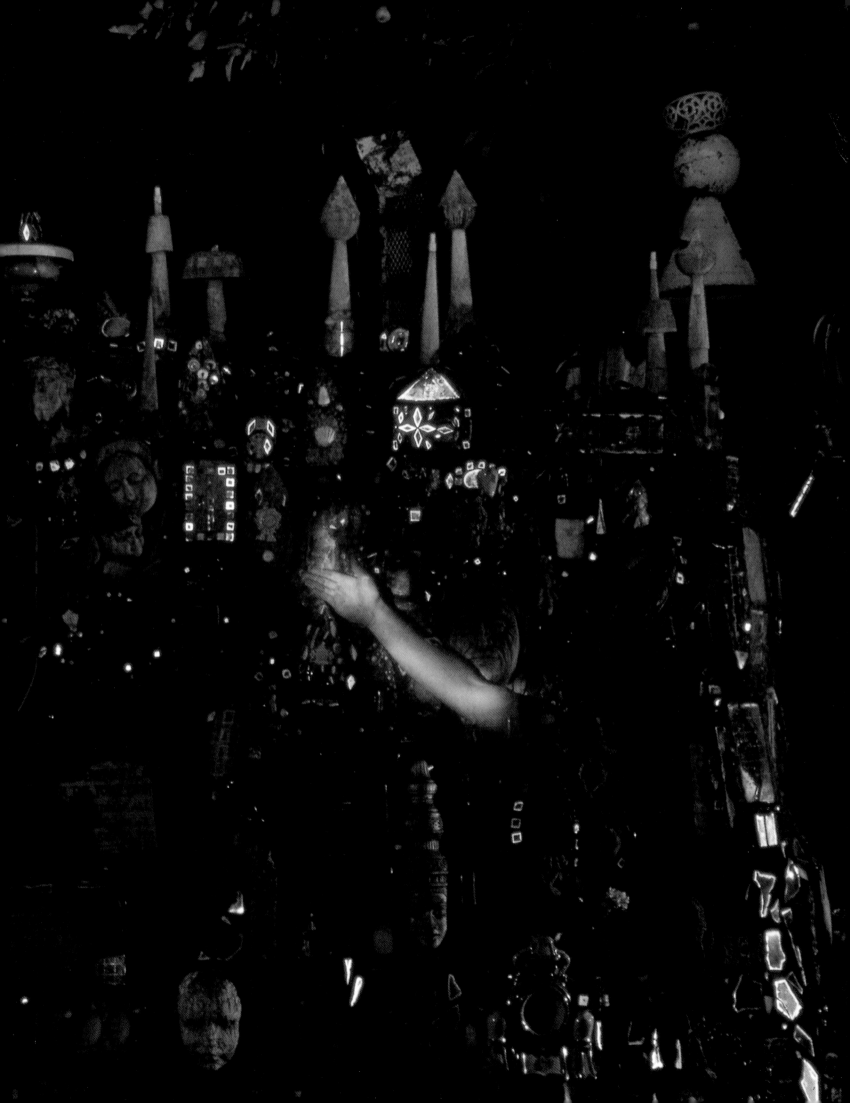

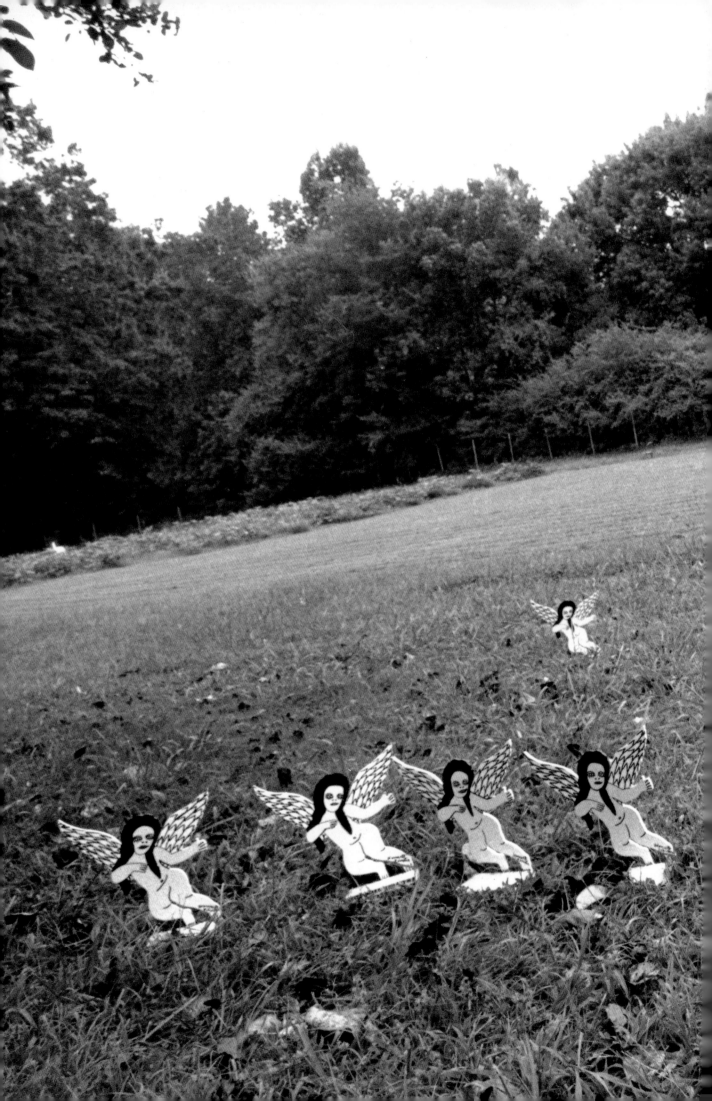

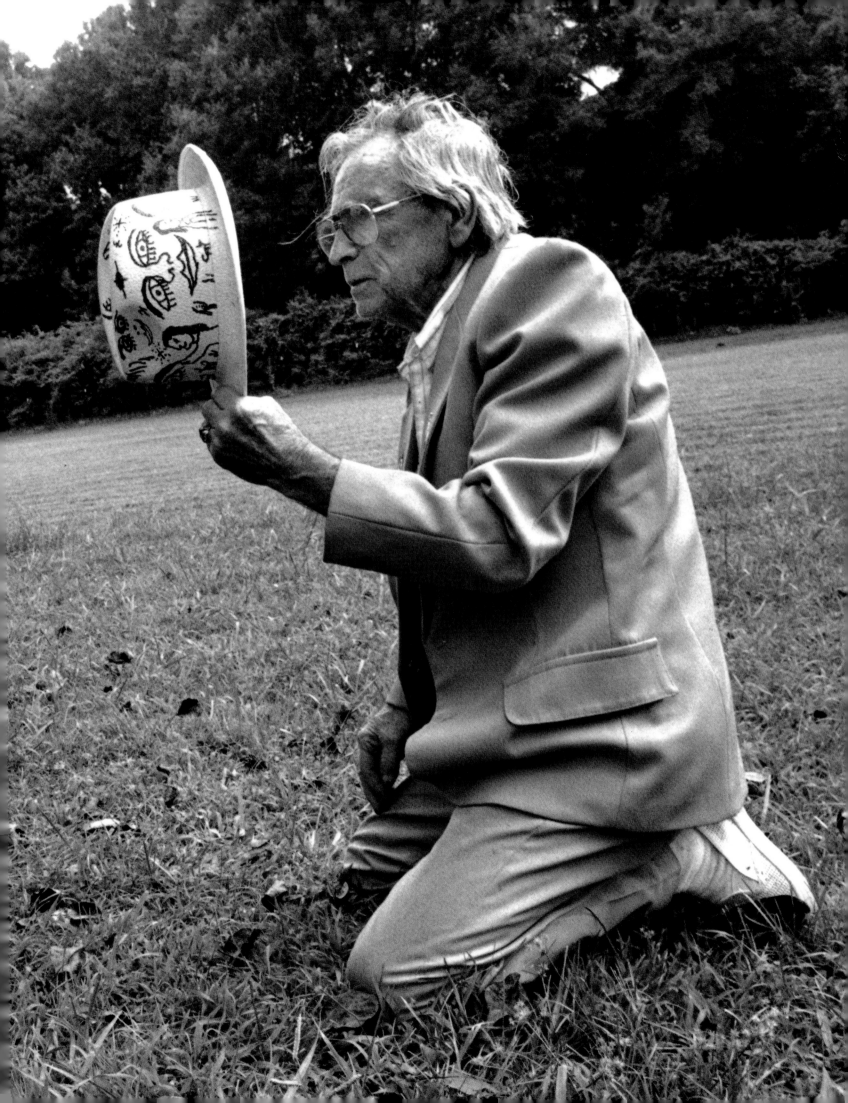

Then I started making bigger sculptures. Every time I found a bunch of bricks that had been throwed away, I'd haul them in with a little trailer. I'd bring in pieces of bricks and brick parts, and I'd make the interior of a monument with them bricks. One of them is like a hen nest where hens can lay their eggs. I've got a water surge comin' in under another one of the monuments. Water runs under it and comes out when it rains. And on up above, I've got a little place, like a little island, with cement ducks cemented in it. It looks like they are swimming. And on up above there, I took a soldier's old steel army helmet; I don't know whose it was. I made a monster head on it, and I left an opening so birds go in and build their nests. They raise their little ones in there, and it's a real good place for them.

My garden is a way for me to get my messages out all over the world. And that's my responsibility. Someday, sometime, people on this planet are going to realize that they need what Howard Finster's got, whether it's religion, whether it's art, or whether it's building a garden. People are going to finally realize, before the end, that they need what Howard Finster's got, and that Howard Finster came here to give it to them. And if they don't want what I want them to have, I'll try to do something they do want, because I'm not a man of confusion. I didn't come to bring confusion. Nobody needs confusion; nobody needs war. Nobody needs terrorist's work. Nobody needs sin. But how do you expect God to give you peace, when you don't want it? That is what I want the world to do when the world comes together, to make peace with one another, then God can spare this world thousands of more years.

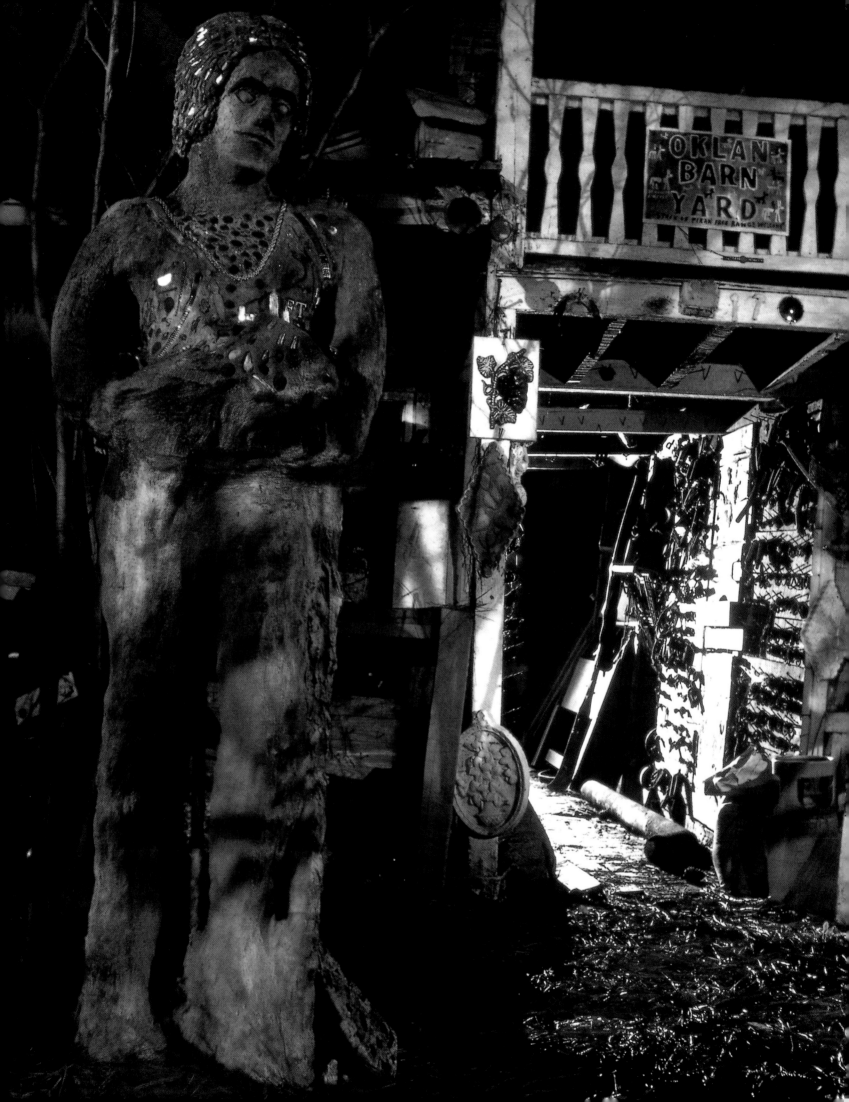

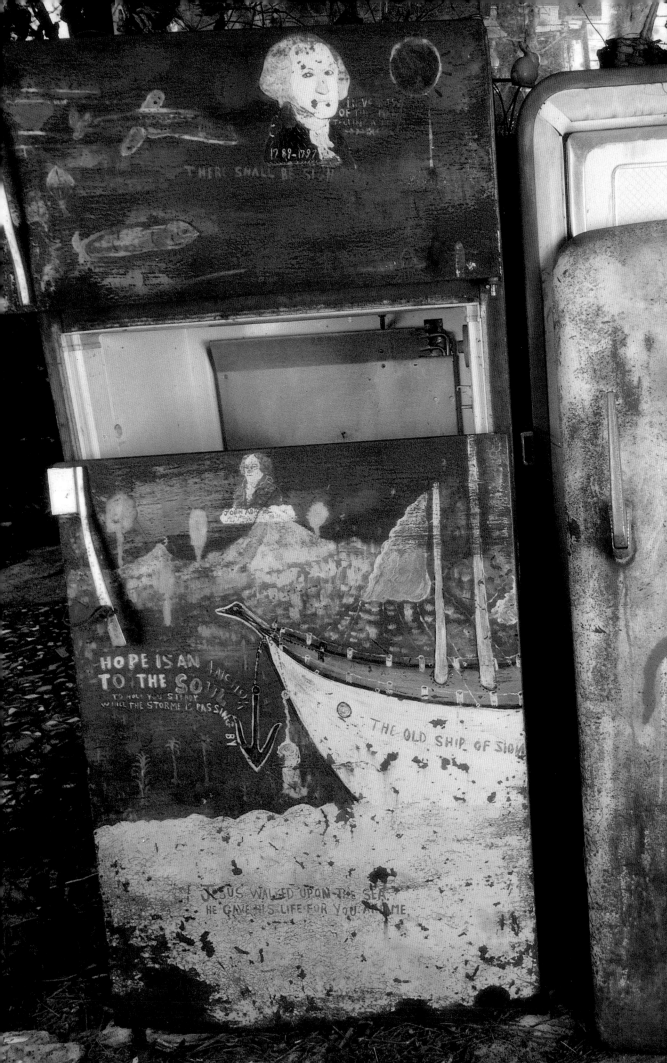

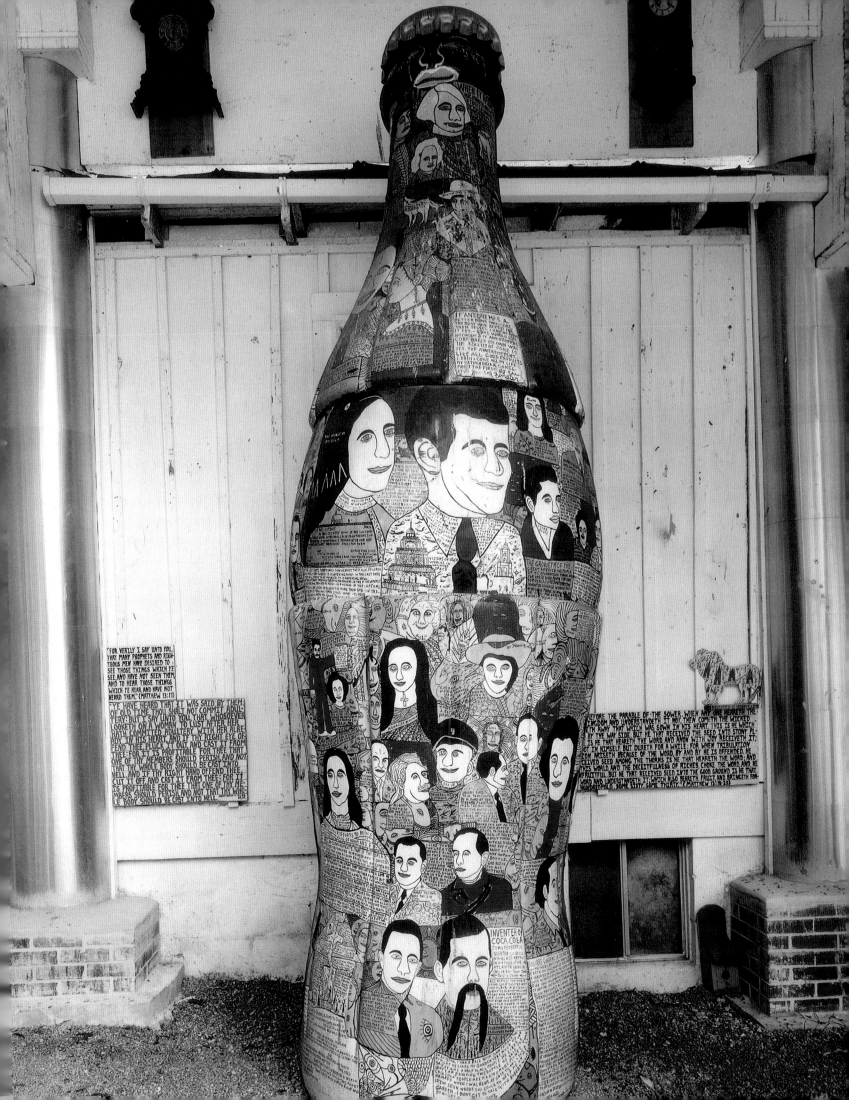

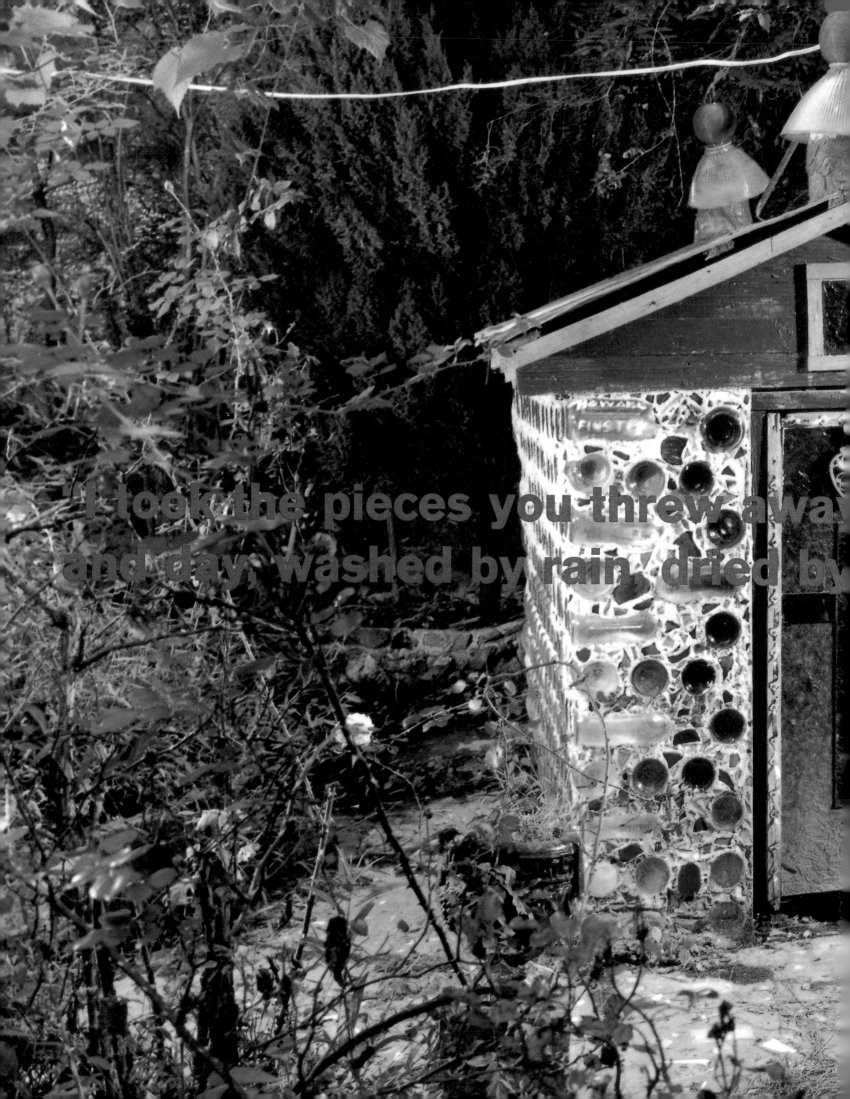

"I took the pieces you threw away and day washed by rain, dried by

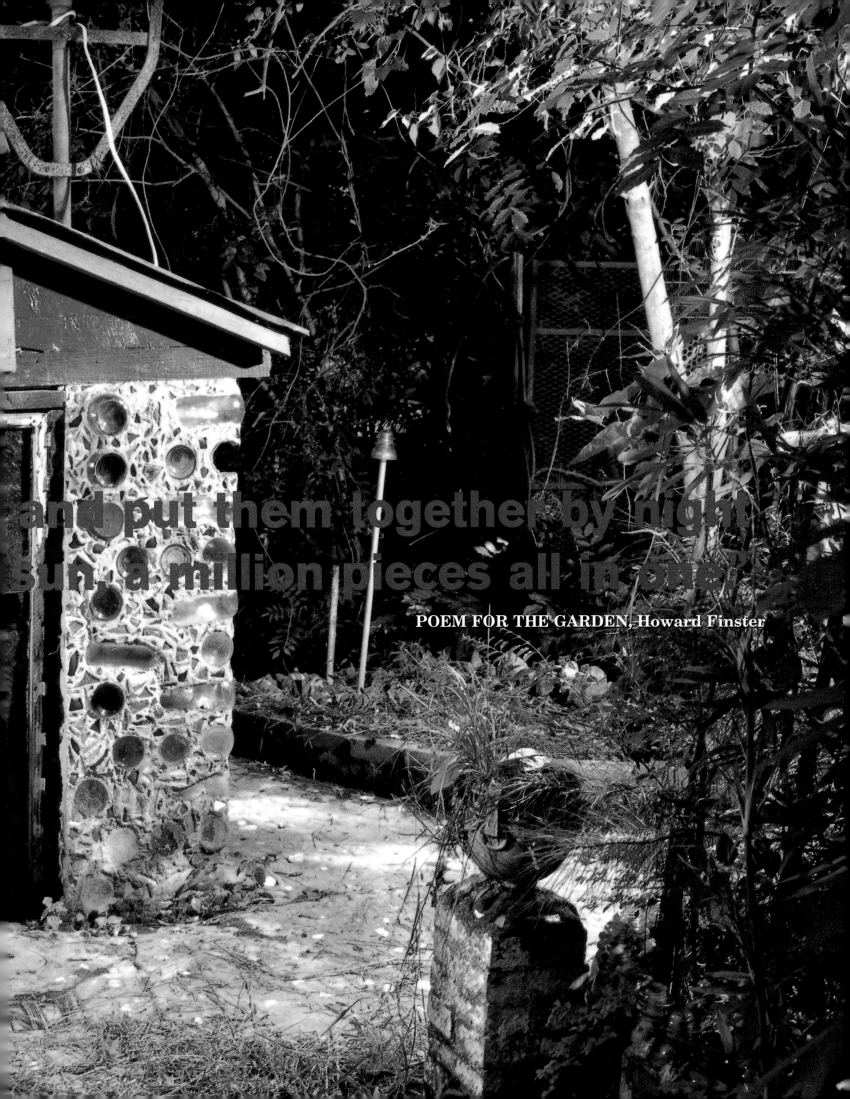

and put them together by night
sun a million pieces all in one.

POEM FOR THE GARDEN, Howard Finster

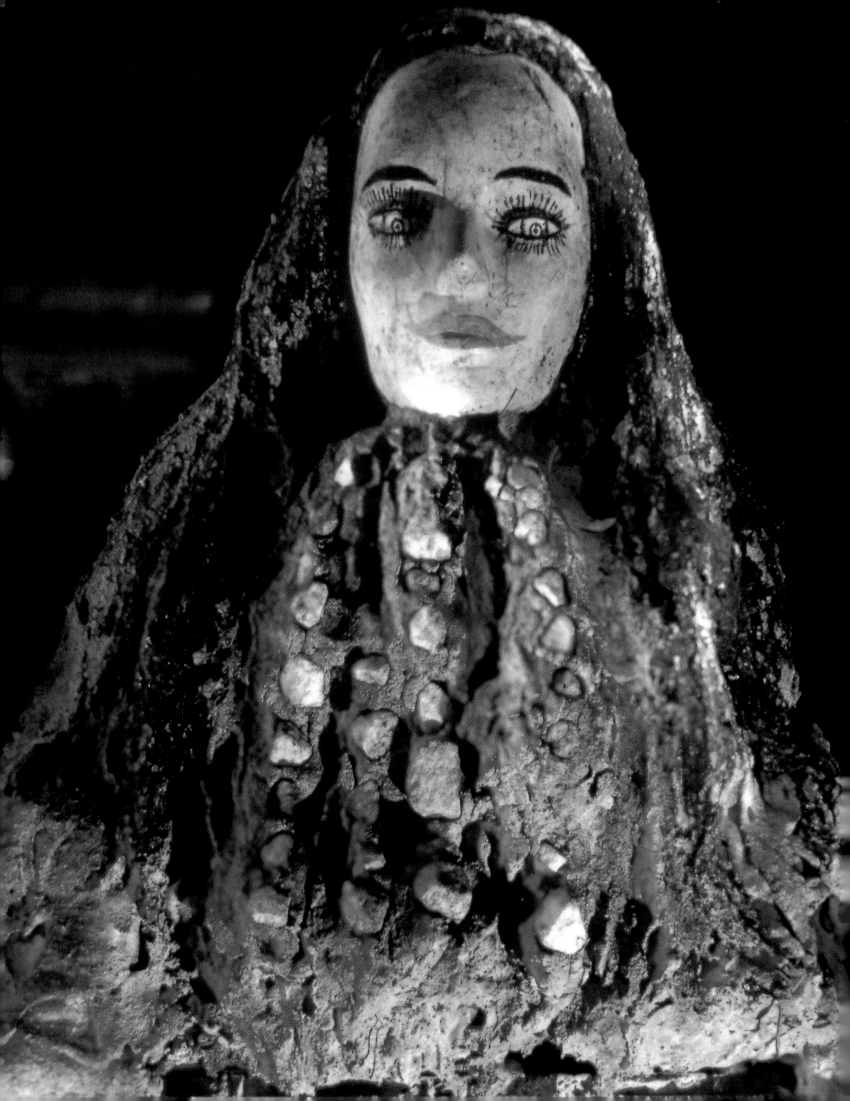

It is pitiful that mankind himself has been destroying the earth and does not know it. Everybody that throws a tin can out their window onto the streets—a nasty habit—does not even realize that they are destroying the world they live in. The Bible says that God said he would destroy those that destroyed the world, and the ones destroying the world is the people. Fish are not destroying the world. Birds are not destroying the world. The wild animals in Africa are not destroying the world. It is human beings—people are destroying the world on which they live on.

My God, people, wake up, we got to get this world to come together. Neighbors to come together. Cities to come together, so we can live a little bit more before we die. In fifty more years, if it keeps going down like it has in the last fifty years, it won't be a fit place for nobody to live, animals or anything.

The Casket of the Unknown Body

A doctor was building him-
self a new home, and he had
to tear down an old Civil War
house to build it. When they
tore the house down, they
found this body buried shal-
low in the floor. They did an
autopsy, and it was a seven-
teen-year-old girl with a
mini-ball hole in her skull,
in the front. Like a Civil War
mini-ball. They had her teeth
all cleaned and everything,
and before the doctor died,
years later, he give me her
body, or what was left of it. I
made a gypsum tomb and put
the bones in there. Of course,
sprouts and things have
growed up in there; it used
to have a glass you could
look through and see her
teeth. But the weather froze
and cracked it, so we finally
had to seal it. The bones
were already a hundred
years old, and it being damp
in there, they've probably
just turned to ashes.

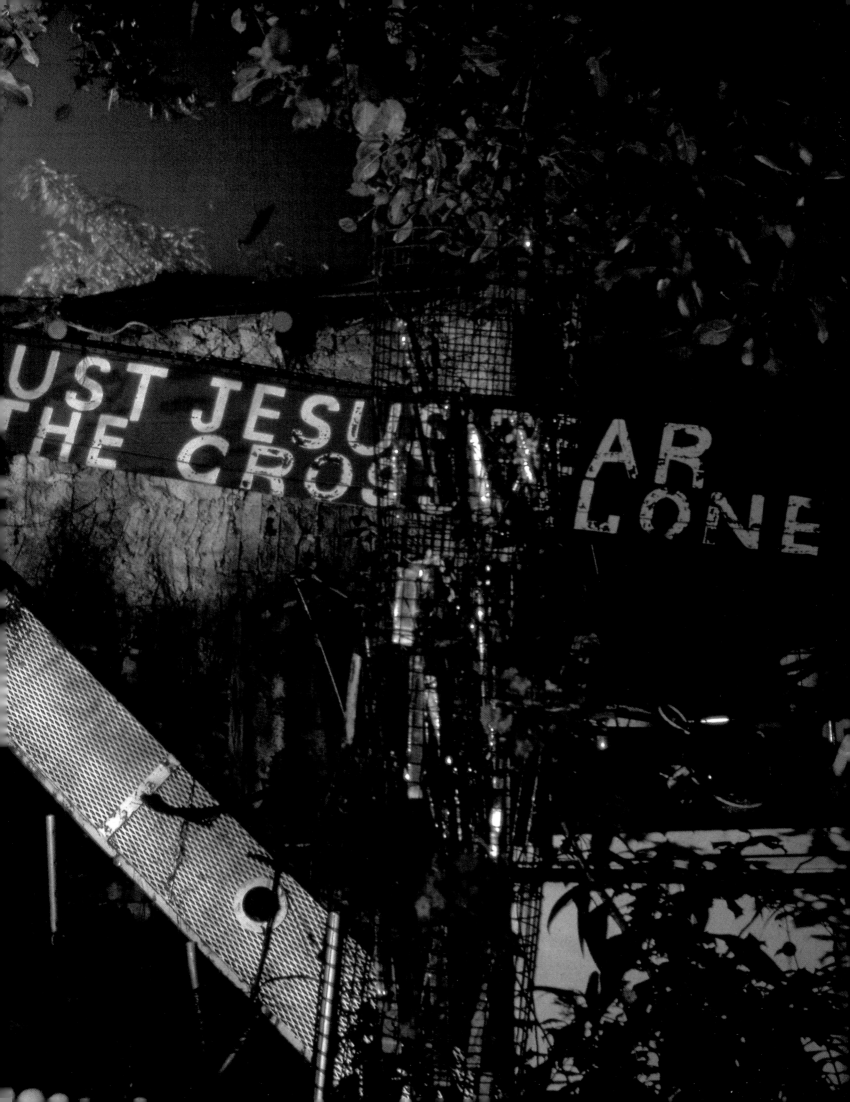

I'm making the marks that I was sent here to make. I'm writing a history that I was supposed to write. My publicity is of my doing; my publicity is from my visions of another world. I don't invite people to come here to publish me, 'cause God takes care of all that. When God tells a TV company to put me on a screen, I'll go on a screen. That's the way God works. If you'll seek God and his kingdom first, all these other things will be added unto you, such as you need, up to his kingdom.

This planet Earth is a big study for me, a big problem for me. My work is mostly finished in this planet, and it's been a real great privilege to meet the people in the planet, to work with them. I've loved and associated with the worst and the best of them—with the infidels, the atheists, the Protestants, the Catholics, the Church of Christ. I've worked along with them, and I've seen what they believe, and they are all my concern. All nations is my concern. Just like if I had a flock of sheep, and one of them was always breakin' over the fence, or another one was always getting wounded or hurt, or another one was absolutely mean, butting around on the rest of them. Doesn't matter, they are all my sheep. I try to work with them and to help them; I love all of them.

The God I serve could give me a million dollars, and I could let it destroy me. Or if he sees fit, he could give me a million dollars, and I could quit painting and finish my garden up. The garden is only half finished. For it to be finished will take a lot of time and a lot of money. If I could do what I feel like, I would like to quit painting art and live in my garden the rest of my life, with the birds and the bees. Thank you and God bless you, this is Howard Finster. This is exactly who Howard Finster is.

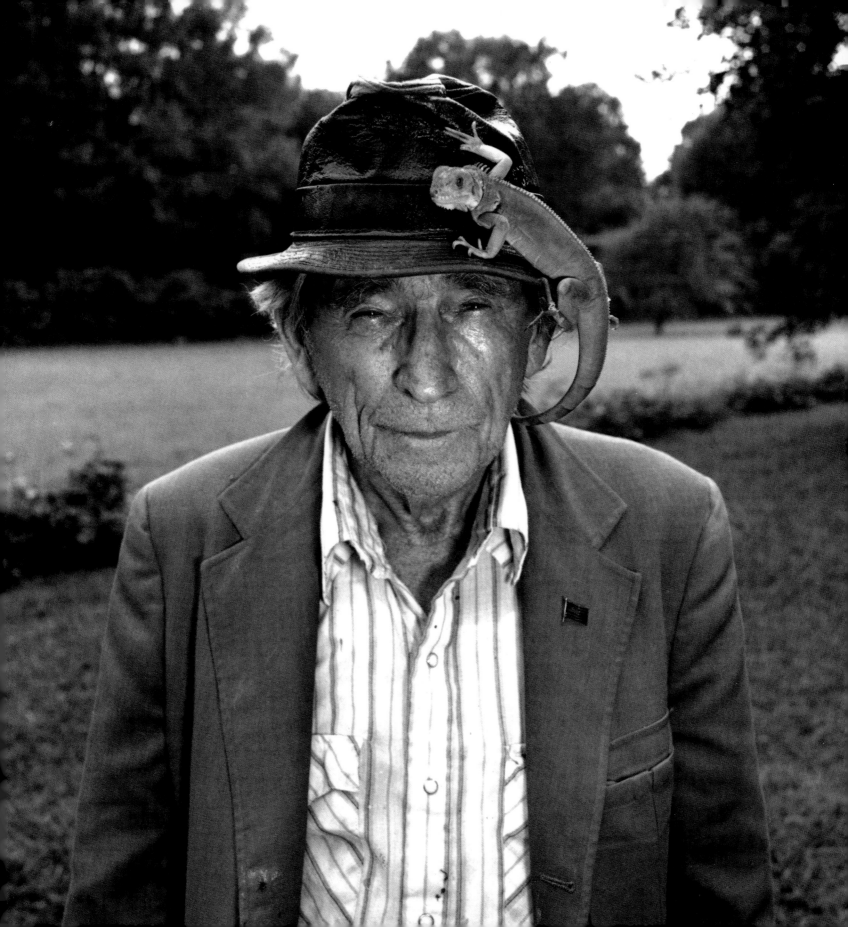

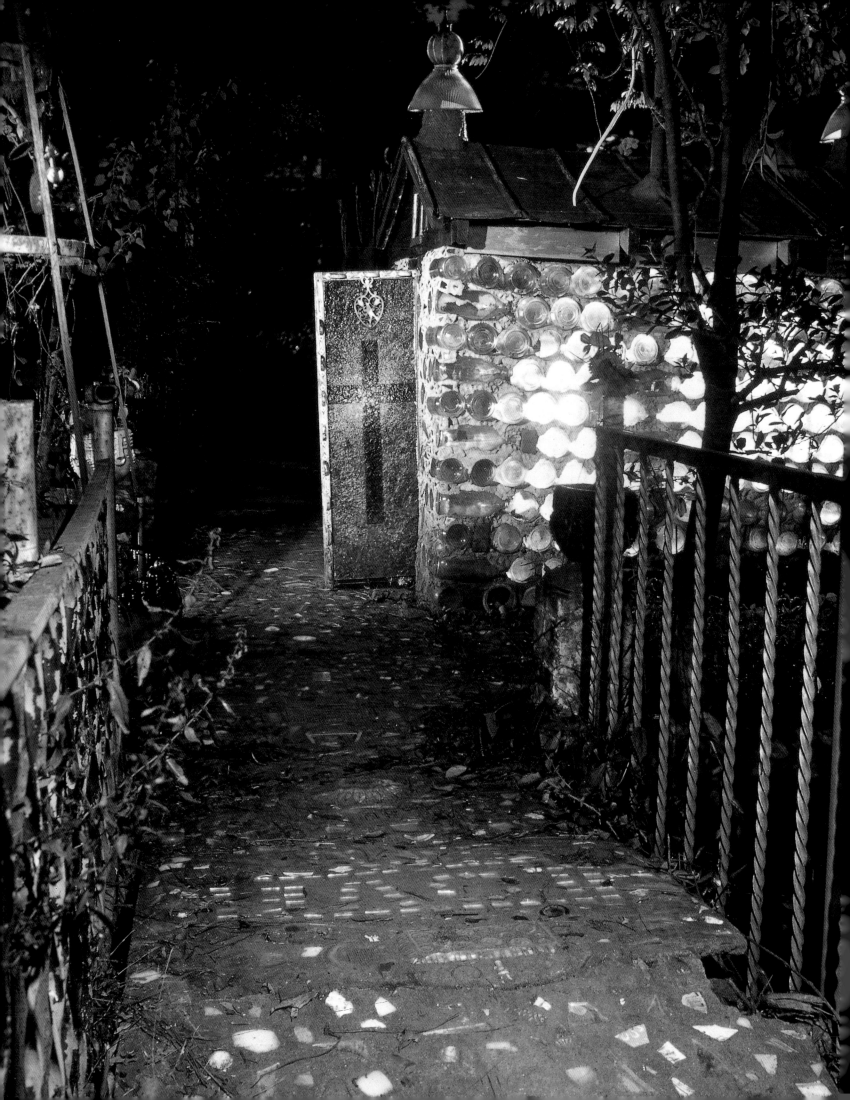

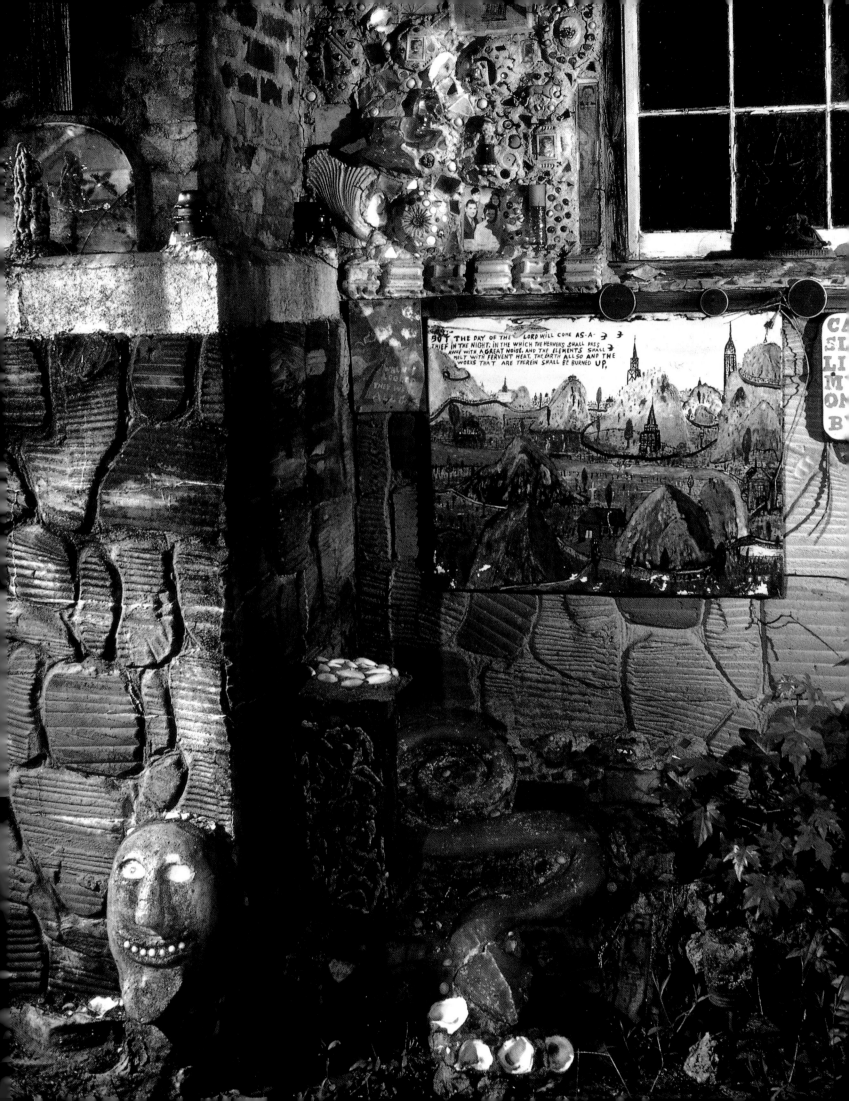

The Front Molding

About fifteen years ago I built that little mansion out there on the road. The bottom part I made of miniature bricks, four inches by two. Those little columns on the house are made from tater chip boxes. I poured those tater chip boxes full of cement, and I made them columns; that round thing on the top is a bicycle wheel. I poured that bicycle wheel full of cement, too. Then I put salt shakers all around it. The thing that goes up there is a piece of rubber like they put down when they are lining the highway. I found one of them at the dump. That other thing is a light fixture. I just poured it full of cement and put rods down in it. The entrance to the garden was right above here, at that gate. Before I built this far over, I used the south end gate. And when I got this far over, I used this entrance here. There's a picture right inside it of a rich man and Lazarus. Some of these paintings have been stolen. That there is Jimmy Carter on one side and John Kennedy on the other side. I honor our former leaders and founders by drawing them and trying to keep their memories living and by remembering their great works, their life stories, and their wisdoms. That was the first big piece of sculpture I ever made.

I had a vision of a cross sixteen foot long, and I put it up there about twelve years ago. I was going to put Peter under it, carrying it. And Jesus. I never did get to that. I started to build it out of wood, which I figured wouldn't last long. A fellow came along while I was working on it, and he said he had some scrap iron in his backyard, said he would take a couple of dollars for it. I brought that steel belt guard. There was exactly enough to make the cross.

That there bomb is a World War II test bomb; they used to practice with it. I got a hold of that from somebody whose name's probably on it. That building behind it is a shed I built, where I put all kinds of machines—typewriters, old office machines, machines that hadn't been used in fifty years or longer. There is a Bible verse says, "And a child shall put his hand on a crockities' den, and it will do him no harm." I went to the dictionary to try to find a crockities snake, and I could not find it in a modern dictionary. I had to get a dictionary from 1918 to find what a crockities was. Crockities is a snake that has radiation in its eyes. It can kill you even without biting you. If it ever gets its eyes set on your eyes, you will die. This represents a child on a crockities' den.

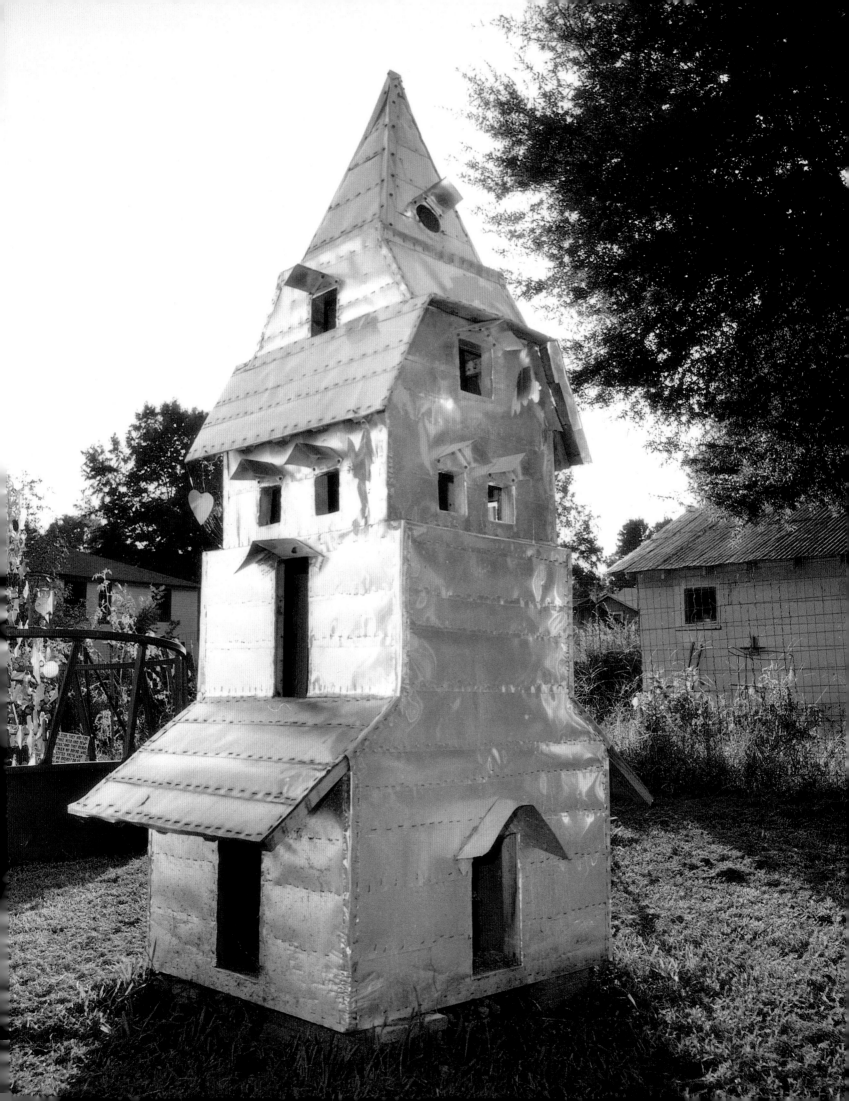

The Folk Art Chapel

One of the largest structures in the garden is the Folk Art Chapel. Where the chapel is, was where Billy Wright's church used to be. He wanted to build a new church, a big church, and he owed $5,000 on that church. He was asking $30,000 for it, and I told him I would try to get it if I could, but the roof was swayed way down, and I could not borrow any money on that. I finally gave up and told him I could not buy it, and he should go ahead and sell it. But he called me one night and said, "Howard, if I could get $30,000 for that church I would not sell it. I am holding it for you. I am going to let you have it for $20,000." And then time rolled on, and I told him all I could do was to save up money to pay on it, and I saved up $8,000 dollars, making clocks and stuff in my wood work. I made furniture, built screen doors and windows. I also fixed lawn mowers and bicycles. I was working full time, pastoring churches, and working every day, except Sunday. I told him, "I tell you what, now I have $8,000 saved up." And he said, "Well good." And I said, "I will pay you the $8,000 and take up the payments on the $5,000 you owe. That will leave me owing you $7,000, and I will sign a side note for it." And so I bought that church. In about a year's time I had that note paid off.

There was nothing you could do but take the whole swayed roof off and build a roof over again. I had a vision of a dome that would cover up that swag, so I started working on it. I went to the saw mill and bought third-grade lumber to frame it, and I got on top of that church and took a fifteen-foot wire. I measured to get the center of the top of the church, then I took that wire and put it on a nail and pulled it out, put a nail on the other end of it, and then went all the way around there from the center. I laid off a thirty-foot roof around the building. When I got to fifteen foot, it was perfectly round. Then I started my plates and a round circle. I measured it off into sixteen corners so I could put windows in there, and when I done that I framed up the first floor level with the top of the roof.

There is a roof museum up there; you can look out and see my exhibits. This fella came along and told me he knowed where I could get masonry stuff, where they were taking it out of a big school, so I bought a lot of masonry stuff for $300. I made a pattern and cut it up into siding shingles. I wanted round posts, but I couldn't afford to buy them. Then I had a vision one night about how to make posts, and I just started sawing lumber up edgeways, out of scraps, like my old chicken house.

I started putting exhibits in the church, and then I had a vision to put a silo right up through the center of it and set it on seven pillars under the church—under the ground—so that silo goes from the ground all the way to the top of the church. I was going to run a little rod out the side of the building and have a little woman churning and a little man cutting wood with a weight that would pull them. He would chop wood for eight hours, all day long, and you could go up in the silo and look down and see everything.

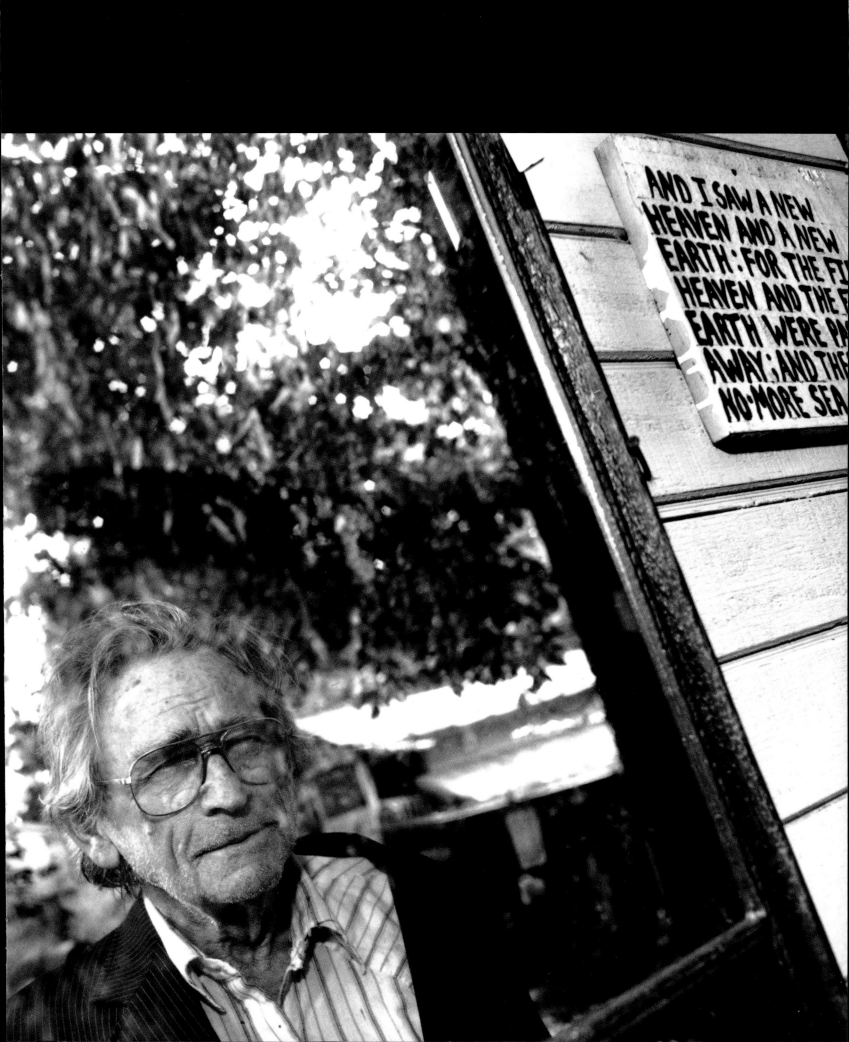

AND I SAW A NEW
HEAVEN AND A NEW
EARTH: FOR THE FI
HEAVEN AND THE F
EARTH WERE PA
AWAY: AND THE
NO MORE SEA

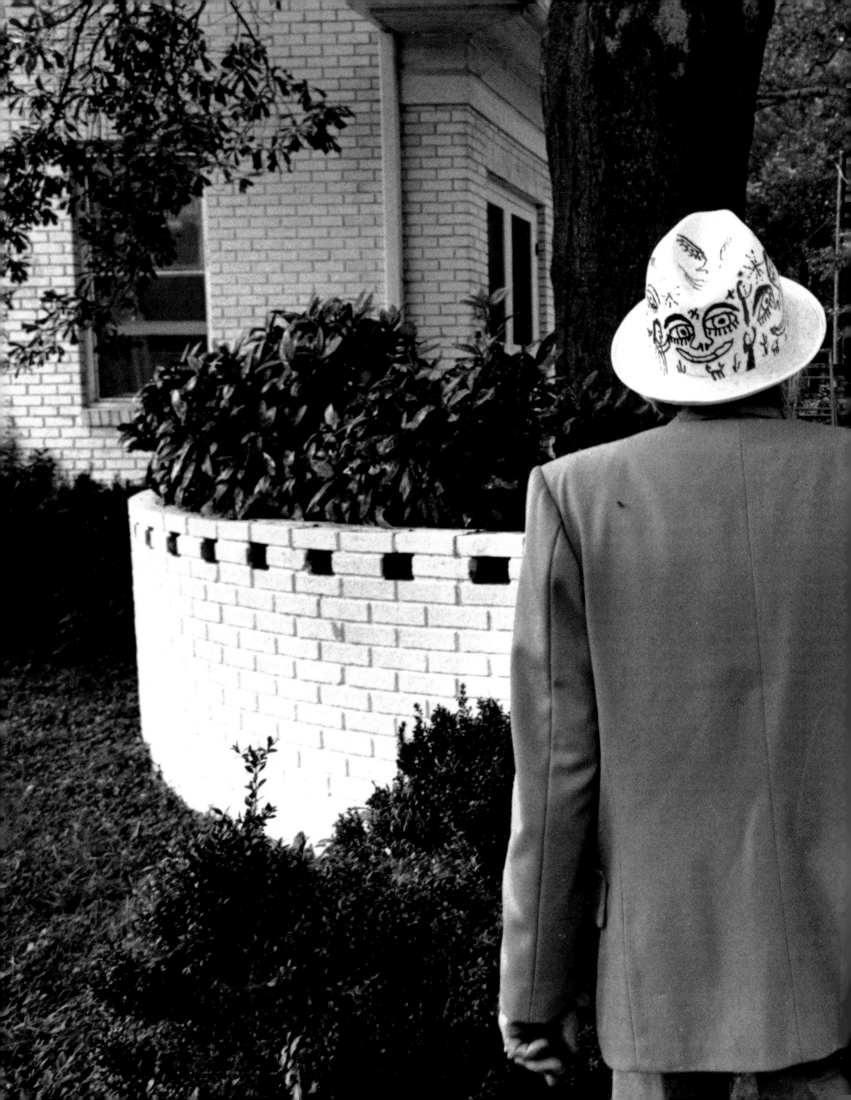

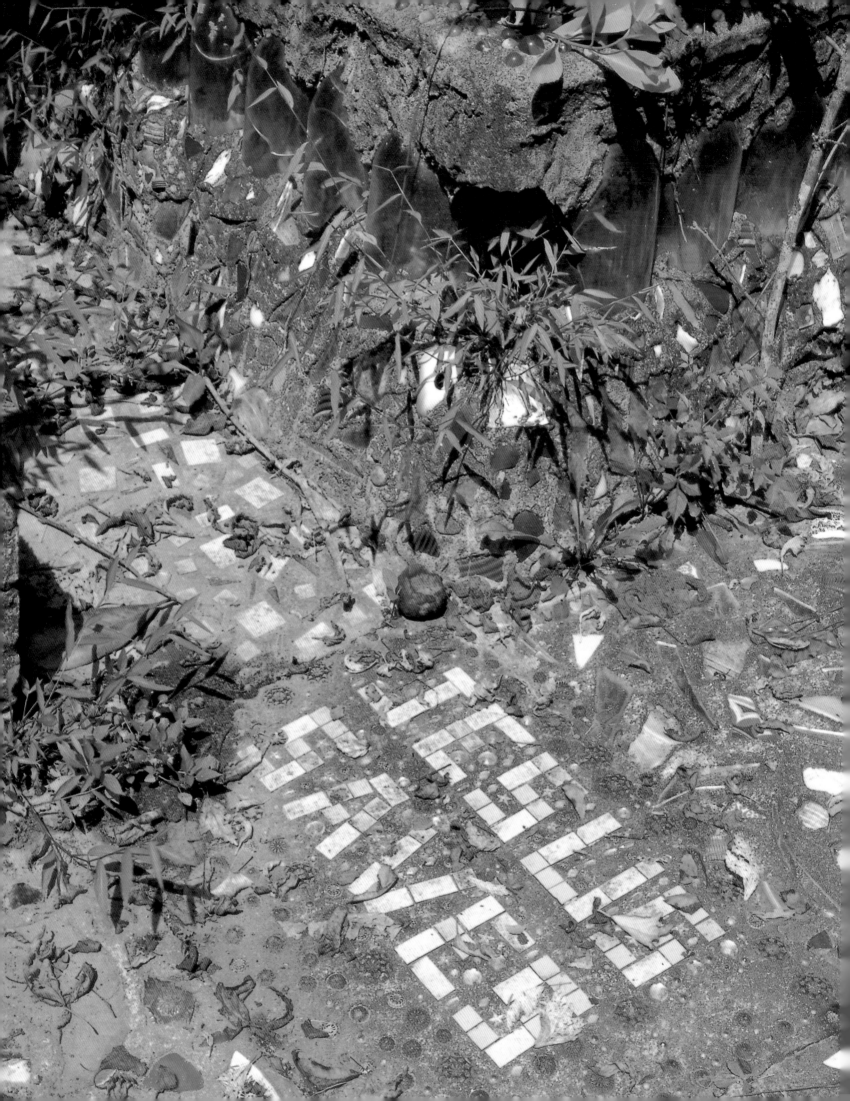

This book is dedicated to Meg Fox for telling me about the Rev. Howard Finster; to Tena Friddell for first taking me to Paradise Garden; to Mike DuBois and Kelly Sinclair; and most of all to Howard and Pauline Finster for the love and time they have shared with me and the rest of the people whose paths they have crossed.

I would also like to acknowledge the following people for their support:

George and Virginia Peacock, Adrian King, Andres Serrano, Carol Kismaric, Marvin Heiferman, William Wegman, Christine Burgin, David Byrne, David Graham, Donald Keyes, John Denton, John Turner, Karekin and Ginger Goekjian, Kate Pierson, Martin Bell, Mary Ellen Mark, Paul Pendergrass, Phyllis Kind, Rick Berman, Ron Jagger, Sandy Skoglund, Tom Patterson, Allen Wilson, Annie Barrows, Gerard Wertkin, John McWilliams, Sarah Rakes, Victor Faccento, Gerard and Rodney McHugh, Roger Gorman, Tim Rollins, Alan David, Beth Lilly, and everybody else I could not think of while writing this.

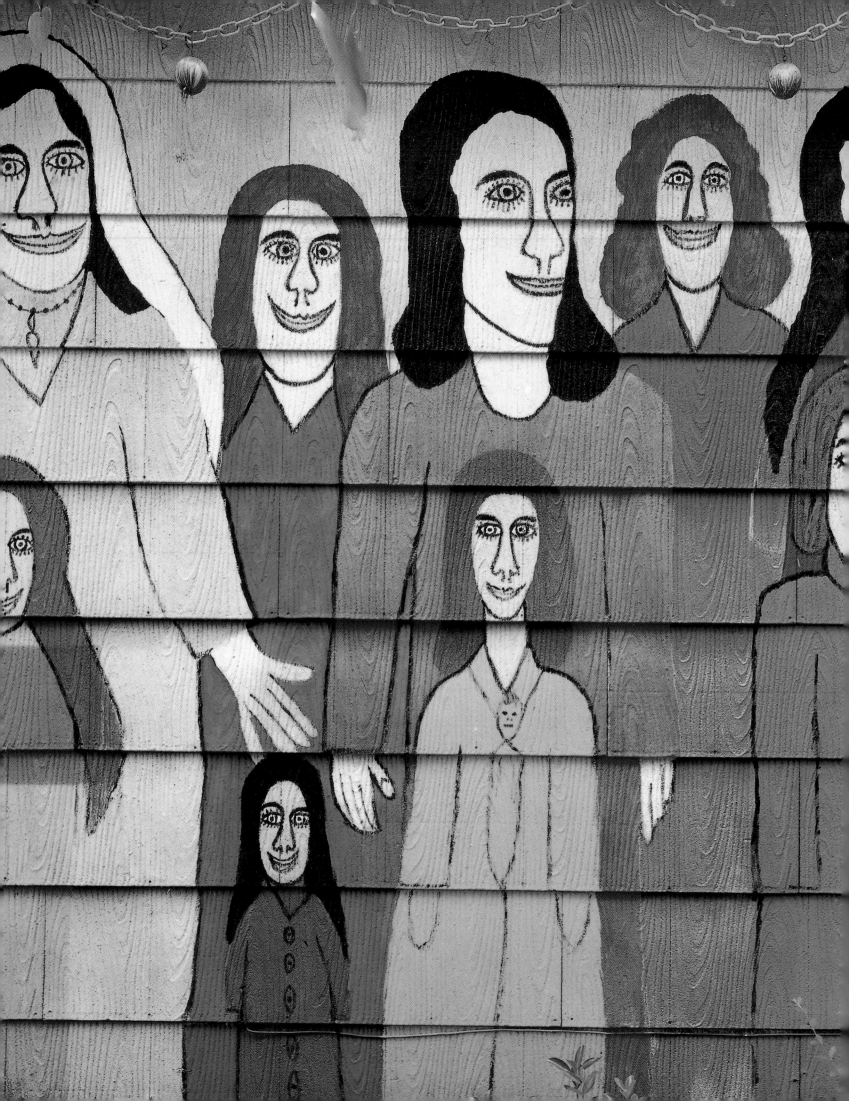

Captions

Page 1: Embedded cement sidewalk, 1992.
 Photograph © by David Graham.

Page 2–3: The Coin Man with bomb, 1992.
 Photograph © by David Graham.

Page 4: Steel Cross, 1992. Photograph © by David Graham.

Page 5: A statue's face, 1988. Photograph © by Alan David.

Page 6–7: Front cement molding with snake, 1992.
 Photograph © by David Graham.

Page inset 7: Replica of a church, 1992.
 Photograph © by David Graham.

Page 8–9: Howard Finster with a flag, 1992.
 Photograph © by Mary Ellen Mark.

Page 10–11: The Bicycle Tower (close up), 1992.
 Photograph © by David Graham.

Page 13: The entrance to garden, 1990.
 Photograph © by Karekin Goekjian.

Page 14: Embedded cement sidewalk, 1992.
 Photograph © by David Graham.

Page 15: The Folk Art Chapel, 1992. Photograph © by David Graham.

Page 16: The Folk Art Chapel and Covered Ramp, 1992.
 Photograph © by David Graham.

Page 17: The Folk Art Chapel (interior close up), 1992.
 Photograph © by David Graham.

Page 18–19: Embedded cement sidewalk, 1992.
 Photograph © by David Graham.

Page 20–21: The Giant Shoe, 1990.
 Photograph © by Karekin Goekjian.

Page 23: Smashed car (message to drunk drivers), 1992.
 Photograph © by David Graham.

Page 24: Center of the garden, 1992. Photograph © by David Graham.

Page 25: Front cement molding, 1992. Photograph © by David Graham.

Page 26: Howard Finster, 1990. Photograph © by Alan David.

Page 27: The Guardian Angel, 1992. Photograph © by David Graham.

Page 28: Mailbox and Toy Train, 1992.
 Photograph © by David Graham.

Page 30–31: Garden path (to the center of garden), 1990.
 Photograph © by Karekin Goekjian.

Page 32–33: Howard Finster in the unfinished covered ramp, 1990.
 Photograph © by Karekin Goekjian.

Page 34: The Bicycle Tower, 1992. Photograph © by David Graham.

Page 36–37: The Serpents of the Wilderness sculpture, 1990.
 Photograph © by Karekin Goekjian.

Page 38–39: The Bible House, 1990.
 Photograph © by Karekin Goekjian.

Page 40–41: Cement molding (close-up), 1990.
 Photograph © by Karekin Goekjian.

Page 42–43: Cement work (close up), 1990.
 Photograph © by Karekin Goekjian.

Page 44–45: Cement molding (close up), 1992.
 Photograph © by David Graham.

Page 46: Cement molding (close up), 1992.
 Photograph © by David Graham.

Page 47: Howard Finster with a flag in front of his face, 1992.
 Photograph © by Mary Ellen Mark.

Page 48: Howard Finster, 1992. Photograph © by Mary Ellen Mark.

Page 51: Howard Finster in the studio, 1992.
 Photograph © by Mary Ellen Mark.

Page 53: Front cement molding, 1992. Photograph © by David Graham.

Page 54–58: Cement molding (close up), 1992.
 Photograph © by David Graham.

Page 59: The Studio (side view), 1992.
 Photograph © by David Graham.

Page 61: Howard Finster with a wooden figure, 1992.
 Photograph © by Mary Ellen Mark.

Page 62–63: Howard Finster, 1992. Photograph © by Mary Ellen Mark.

Page 64: Howard Finster on his bicycle, 1992.
 Photograph © by Mary Ellen Mark.

Page 66: Howard Finster with sculpture, 1992.
 Photograph © by Mary Ellen Mark.

Page 67: The Bible House (interior), 1992.
 Photograph © by David Graham.

Page 68–69: Parking Meter, 1992. Photograph © by David Graham.

Page 70–71: The Cadillac, 1992. Photograph © by David Graham.

Page 72–73: The Bird House, 1992. Photograph © by David Graham.

Page 75: Cement molding, 1992. Photograph © by David Graham.

Page 76–77: The Covered Ramp, 1992.
 Photograph © by David Graham.

Page 78: Bridge in the garden, 1992. Photograph © by David Graham.

Page 79: The Folk Art Chapel (exterior close up), 1992.
 Photograph © by David Graham.

Page 81: Garden detail, 1992. Photograph © by David Graham.

Page 82–83: Cement molding (close up), 1992.
 Photograph © by David Graham.

Page 84–85: Interior of the front molding, 1992.
 Photograph © by David Graham.

Page 86–87: Garden woodwork, 1992.
 Photograph © by David Graham.

Page 86 inset: Howard Finster lying in the grass, 1992.
 Photograph © by Mary Ellen Mark.

Page 87 inset: Howard Finster lying in the grass with his hat, 1992.
 Photograph © by Mary Ellen Mark.

Page 88–89: Garden exterior with baby doll, 1992.
 Photograph © by David Graham.

Page 90–91: Howard Finster, 1992. Photograph © by Mary Ellen Mark.

Page 92–93: Cement molding with arms, 1990.
 Photograph © by Karekin Goekjian.

Page 94–95: Howard Finster holding his hat, 1992.
 Photograph © by Mary Ellen Mark.

Page 97: The Coin Man, 1990. Photograph © by Karekin Goekjian.

Page 98: Refrigerator art, 1992. Photograph © by David Graham.

Page 99: The Coke Bottle, 1992. Photograph © by David Graham.

Page 100–101: The Pump House, 1992.
 Photograph © by David Graham.

Page 102: The Mother and Child sculpture (close up), 1990.
 Photograph © by Karekin Goekjian.

Page 104–105: Must Jesus Bear The Cross Alone, 1990.
 Photograph © by Karekin Goekjian.

Page 107: Howard Finster, 1992. Photograph © by Mary Ellen Mark.

Page 108: The Pump House, 1990.
 Photograph © by Karekin Goekjian.

Page 109: Building and painting, 1990.
 Photograph © by Karekin Goekjian.

Page 111: Tin Chapel, 1992. Photograph © by David Graham.

Page 113: Howard Finster, 1992. Photograph © by Mary Ellen Mark.

Page 114–115: Howard Finster's back, 1992.
 Photograph © by Mary Ellen Mark.

Page 116: Embedded sidewalk (Jesus saves), 1992.
 Photograph © by David Graham.

Page 118: The Studio (close up), 1992.
 Photograph © by David Graham.

Page 120: Main trail sign, 1992. Photograph © by David Graham.

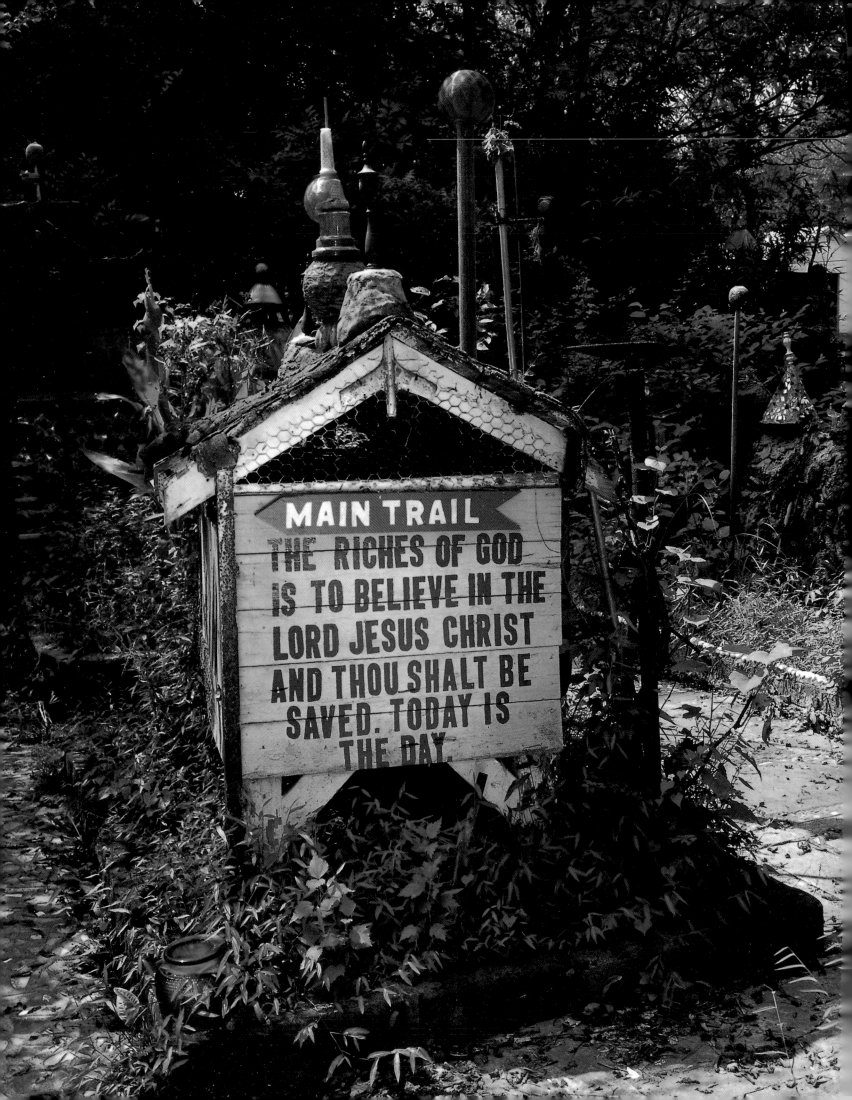